Clara Hatton:
A Vision for Art at CSU

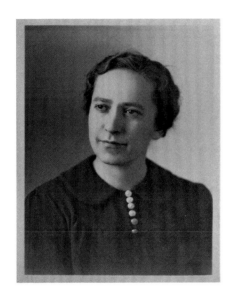

Essays by Bill North and Emily Moore

GREGORY ALLICAR **MUSEUM OF ART**

COLORADO STATE UNIVERSITY

Clara Hatton: A Vision for Art at CSU

Published to accompany the exhibition *Clara Hatton: A Vision for Art at CSU*
 February 8 – June 20, 2021

©2021 Gregory Allicar Museum of Art, Colorado State University
ISBN: 978-1-7323476-2-5

Gregory Allicar Museum of Art
Colorado State University
Fort Collins, CO 80523-1778
Tel: 970-491-1989 | artmuseum.colostate.edu

Editor: Lynn Boland
Designer: Silvia Minguzzi
Photographer: Gary Huibregtse, unless noted
Printed and bound by Frederic Printing Company

Cover image: Clara Hatton (1901–1991), *Pine and Aspens* (detail), 1930s, linen over paperboard, 24 x 20 inches, courtesy of Don and Carol Hatton; title page image: photograph of Clara Hatton ca. 1944.

Contents

Foreword

There seem to be certain archetypes within academia of the United States. One is The Art Department Founder. More often than not, for state schools especially, this is tied to a regionalist style, an art movement in the U.S. of the 1930s and 1940s that focused its realist style on rural life and small towns, especially in the Midwest. There was often a certain bravado among these artists and associations with masculinity abound. While Clara Hatton was not the only woman to found an art department in the United States during this era, it wasn't the norm and in this, she enriches this model in important ways.

Art departments founded at this time demonstrated a common can-do spirit of the Depression Era, an unflinching determination in the face of endless challenges. As we prepare, in 2020, to present this exhibition and publication in early 2021, Clara Hatton's story of determination and dedication to art and education resonates all the more. The challenges we face look very different but the way through is perhaps much the same.

It is not unusual for The Art Department Founder to also be tied to the founding of the university's art museum, in one way or another. Although Clara Hatton did not have a direct hand in its founding, the Gregory Allicar Museum of Art née University Art Museum, grew out of the Hatton Gallery in the Department of Art and Art History. Clara Hatton will always have a special place of honor within the museum's collection and galleries. My colleagues within the museum join me in offering our profound thanks and compliments to all involved in bringing this important project to life, and I offer my sincere thanks to each of them—Suzanne Hale, Keith Jentzsch, Caity Minard, and Silvia Minguzzi—for their commitment to visual art and education day in and day out. We also offer our profound and ongoing thanks to Prof. Gary Huibregtse for his exquisite collection photography.

Another familiar and beloved archetype of academia, especially among university museums, is The Family Archivist. Usually a member of the generation to follow, for so many artists of note and significance but without great fame, this role is essential to our shared cultural history. In preserving Clara's story, we have her niece Ora Shay to thank, and profusely,

without whom so much of this rich and relevant history would be lost or remain scattered. Ora also deserves special thanks for her amiability and support during the countless changes to project plans, and for her valuable and tireless assistance during the editorial process for this catalogue. We are also tremendously grateful to all the lenders for this exhibition and all of those who lent their knowledge and expertise to this endeavor. I join the project's curators in offering my sincere thanks to them all.

Of the archetypes of the university museum, The Scholarly Curator is undoubtedly the most numerous; however, the contributions of Emily Moore and Bill North to this project are anything but common. Their assiduous research, thoughtful analysis, and compelling writing give flesh and form to the anecdotes so often repeated throughout our halls, while sussing out nuance and truth. The museum is deeply grateful for their considerable contributions to our shared history.

Like the earliest faculty of CSU's Art Department, the scholars behind this project, Moore and North, faced an uncertain and changing academic and cultural landscape. Like their predecessors, their determination proved essential as the plans for this project have been repeatedly upended by a global pandemic. Originally scheduled for Summer 2020, the exhibition opening date has changed six times since March of that year. Although this publication lists dates for display, it remains anyone's guess as to whether or not those dates prove correct.

This project marks an important moment, not just for Colorado State University, but for the history of art in the United States. In our current context, Hatton's story means all the more. The Department of Art and Art History at CSU is dedicated to the principle that the visual arts are fundamental to intellectual life. This principle rings true regardless, but we have Clara Hatton's vision and determination to thank for setting us on a path to realize it at Colorado State University. ❖

Lynn E. Boland, PhD
Director and Chief Curator
Gregory Allicar Museum of Art
Colorado State University

Acknowledgments

Clara Hatton: A Vision for Art at CSU came together through the goodwill of many individuals, particularly as we dealt with the pandemic of COVID-19. The exhibition was originally scheduled to be installed for the summer of 2020. In the wake of the pandemic, our initial disappointment at not being able to open the exhibition as scheduled quickly turned to worry that it might not be possible to install it in the fall. But fortunately, the doors are finally open, and we can show these works of art and tell the story of Clara Hatton, a story that waited for many years to be told.

First and foremost, we thank Ora Hatton Shay, Clara Hatton's niece, for her vision in mounting a Clara Hatton exhibition at Colorado State University. Ora contacted art historians at CSU in July 2019 with her idea; she and her husband, Jim, visited campus in late August 2019 to share images of more than two hundred works of art by Clara Hatton. Many of these works are in Ora Shay's personal collection, the result of decades of work to re-assemble her aunt's oeuvre after an estate auction that dispersed it in 1991.

Ora also connected CSU with Bill North (Director, Clara Hatton Center, Salina, Kansas) who brought to the project his expertise in exhibition planning, his keen eye for works on paper, his long-term interest in Clara's work, and a deep love for Hatton's Kansas home. In January 2020, Bill and CSU art historian Emily Moore had the treat of staying for a long weekend at Ora and Jim Shay's home in Austin, Texas. There we studied many of Hatton's pieces in person and began to comb through the archive that Ora had valiantly organized of Hatton's correspondence, photographs, and related material. We thank Ora and Jim for their hospitality and collaboration through many months of research.

We would also like to thank the numerous family members who granted us interviews in fall 2019 and spring 2020, some of whom generously lent their "Claras" for this exhibition. In Colorado, these include Ed and Judy Schade of Palmer Lake (Ed is Ora's brother and Clara Hatton's nephew); Helen and Dick Rewey of Longmont (Helen is also Hatton's niece); and Greg Gillin of Centennial (Greg was married to the late great-niece of Hatton, Susan Gillin). Thank you also to Bob Shay of Denver, who made a heroic ten-hour drive to bring *Pine and Aspens* from Don Hatton's summer home in Crested Butte back to Denver in

time for us to whisk it to Fort Collins for a photo shoot. And thank you to Don and Carol Hatton for lending the painting to us, as well as lending us several other works from their collection in Lawrence, Kansas, and for providing information about Clara Hatton's life. Others in Kansas who contributed to this exhibition include Gretchen Esping, Todd Goodheart (Clara Hatton's great-nephew), DJ Hatton (another great-nephew of Clara), Paula Neuer, Karla Prickett, and Martha Rhea.

CSU colleagues who shared their memories of Clara Hatton include Dave and Pat Dietemann of Fort Collins, the former whom Hatton hired to teach painting at CSU in 1957 and the latter who studied pottery with Hatton in the 1950s. The Dietemanns surprised us by inviting to the same interview Judy Dunn, widow of John Sorbie, whom Hatton had hired to teach graphic design in 1958, as well as Judy's husband Guy Dunn, from whom we learned more CSU history. Dave and Joan Yust met us at a local café for an interview, recalling their memories of Hatton as her colleague and student, respectively. Perry Ragouzis, chair of the CSU Art Department following Hatton's retirement, generously arranged a phone interview with us during the isolation period of COVID-19. Perhaps most poignant was our November 2019 interview with John ("Jack") Curfman, whom Hatton hired in 1946, and who taught at CSU for the next fifty-one years in both art and design & merchandising. Jack and his companion, Steve Murphy, visited us on campus (in a wheelchair for Jack, who was in his 90s, and with a walking stick for Steve, who is blind), in order to talk about Clara Hatton, Jack's "beloved mentor." As it turned out, this was the last time Jack would visit the art department at CSU; he passed away on March 24, 2020.

In Denver, Karen Jones, a master bookbinder and former librarian at CSU who had taken an interest in Clara Hatton many years ago, generously shared a thick folder of her own research on Hatton's life. Karen also took the time to catalogue all of Hatton's books that are displayed for this exhibition, and we sincerely thank her for so generously sharing her expertise. Cynthia Lawrence, a painting conservator in Denver, stopped midway through her treatment of Hatton's *Red Tree* painting when she learned that we were interested in showing Hatton's process as part of this exhibition; she also shared

her knowledge of Hatton's painting techniques. At Colorado State University, many thanks go to Vicky Lopez-Terrill of Morgan Library's Archives & Special Collections, who schooled us in the confusing evolution of names of Colorado State University and who pulled dozens of course catalogues to review the history of the art curriculum in Fort Collins. Anna Bernhard of the Department of Art & Art History's Wold Resource Center shared her own extensive research on department history and set up lights, cameras, and tea for our interview with Jack Curfman in November 2019. Sanam Emami (associate professor of pottery), Haley Bates (associate professor of metals), Tom Lundberg (professor emeritus of fibers), and Kristen Bukowski (instructor of fibers) each lent their expertise to discern the techniques and materials of Hatton's "handcraft." Gary Huibregste, Professor of Photo Image Making, photographed the art that graces this catalogue.

At the Gregory Allicar Museum, Dr. Lynn Boland supported this exhibition from the get-go and patiently ushered us through missed deadlines and the delays of COVID-19. Suzanne Hale, kept the art safe through the pandemic; Keith Jentzsch mounted it beautifully in the gallery. Silvia Minguzzi awed us once again with her graphic design skills for this catalogue.

Finally, we thank Clara Hatton for leaving us with such a wide array of artwork, and for her tireless efforts to establish an art department in northern Colorado. It has been humbling to study her accomplishments in so many mediums and to retrace her decades of dedication to the art department at CSU. Thank you, Clara! ❖

Emily Moore,
Associate Curator of North American Art,
Gregory Allicar Museum of Art, and
Associate Professor of Art History,
Department of Art and Art History,
Colorado State University

Bill North,
Director, Clara Hatton Center,
Salina, Kansas

The Life and Art of Clara Hatton

Introduction

Writing from London on November 12, 1935, to her brother Lloyd, Clara Hatton declared:

> But I think I could really make a mark here if I stayed longer. Except in wood engraving I am doing very well now. Anyway I still think if I used the 500 to fix up a studio in Lawrence and really put my shoulder to the wheel I could do a lot and who asks how long one has studied where? It should and does tell in the quality of the work produced.[1]

Hatton, an instructor in the Department of Design at the University of Kansas in Lawrence (KU), was in London while on leave from her teaching duties for the 1935–36 academic year. She was abroad furthering her study of printmaking and bookbinding at the Royal College of Art and the Central School of Arts and Crafts, two of London's most venerable art schools. The artist's brother Lloyd, a physician in Kansas, underwrote her expenses and tuition. Hatton was torn between staying in London for an additional term of study and returning to her native Kansas. The former would require an additional five hundred dollars of support from her brother, a sum which would, as the artist notes, go a long way toward setting up a studio.

Hatton's letter, like much of her correspondence to family back in Kansas during her year overseas, reveals an artist at a significant crossroads in her professional life. By this time, Hatton had been associated with the Department of Design at the University of Kansas, either as a student or an instructor of design and lettering classes, for nearly fifteen years. As a university instructor without an advanced degree, her financial position and opportunities for advancement within the university were severely limited compared to her colleagues in the professorial ranks, especially in the midst of the Great Depression. Now, she was grappling with the challenge that has bedeviled artists with vocational aspirations for generations— the business of sustaining a life and career as a working artist.

Thankfully, Hatton did not stay abroad beyond 1936. She returned stateside just in time to teach during the 1936 summer term at the University of Kansas, her final assignment at the institution. Later that year, the Department of Home Economics at Colorado State College of Agriculture and Mechanic Arts (now Colorado State University) hired Hatton to teach art. Thus began her thirty-year tenure as the visionary leader of Colorado State University's art department. By the time she retired in 1966, Hatton had transformed what began as a small unit within the Department of Home Economics into a full-fledged department

1 Clara Hatton to Lloyd Hatton, November 12, 1935, Shay family collection.

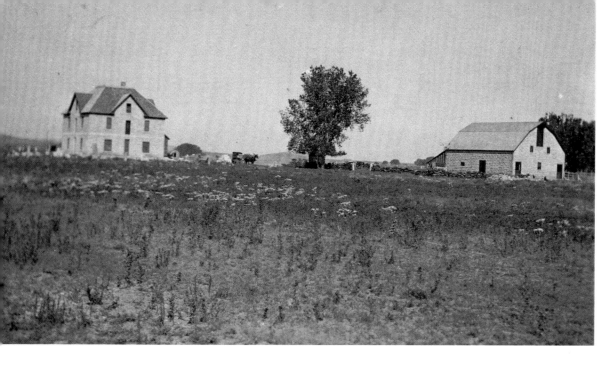

Figure 1. Hatton family farmstead, Russell County, Kansas.

within Colorado State University's College of Science & Arts with a faculty of twenty and nearly 400 majors. Her work is the foundation on which Colorado State University's present Department of Art and Art History is built. What follows is a brief overview of Hatton's life and art, from her childhood on the windswept Kansas prairie to post-retirement in Salina, Kansas.

Early Years in Kansas, 1901–21

Clara Anna Hatton, the daughter of Apollonia (née Klein, 1882–1980) and Lemeon "Lem" Hatton (1873–1938), was the firstborn of six children.[2] She was born October 19, 1901 in a modest wood house on the family's 160-acre farm in Russell County, Kansas, in the innermost interior of the United States.[3] Nestled in a large, lazy bend of the Saline River, the land on which Hatton was born and raised is approximately sixty miles due south of the geographic center of the contiguous United States. Lem built a massive, two-and-a-half-story house and a large barn, both of which were constructed of locally quarried limestone (fig. 1). Forty feet square, the house included a full basement with a furnace and space for winter storage of root vegetables; main floor with kitchen, parlor, dining room, and

2 Hatton's siblings were: Ora Adehlia (1904–2001); Lloyd William (1906–93); George Edward (1908–99); Edith Louise (1910–97); and Ruth Ada (1919–24).

3 Adjacent to the north of Russell County is Osbourne County, the setting for *Sod and Stubble*, John Ise's 1936 "nonfiction novel" recounting the experiences of Henry and Rosa Ise from the 1870s to the turn of the century. See *John Ise, Sod and Stubble: The Unabridged & Annotated Edition*, with additional material by Von Rothenberger (Lawrence: University Press of Kansas, 1996).

guest room; four bedrooms on the second floor; and a large attic, which was often used for square dance parties.[4]

Growing up on the Kansas prairie instilled in Hatton a strong sense of self-reliance and resilience that would serve her well as an artist and a professor. Life on the farm was hard but full. According to Ora Hatton Shay, Hatton's niece:

> Water had to be brought in from the well just outside the kitchen door. The furnace in the basement provided the heat for the house, so a supply of wood and coal had to be laid

in each fall. The garden and animals that the family raised provided their food. The indoor plumbing was added in the 1940s, years after the house was completed. Electricity and telephone were also slow to come. School for the children was just over a mile away, so in bad weather, the horse was hitched to a wagon and the children drove themselves to the schoolhouse. On good weather days, they walked. Shoes were a luxury they allowed themselves only in the winter, and even then, they were handed down from one child to the next.[5]

Culture and education were high priorities in the Hatton household. Hatton's mother made sure of

4 Information about the Hatton house is from Ora Hatton Shay, "Clara" (unpublished manuscript, last modified October 17, 2019), Microsoft Word file; with additional information from Ora Hatton Shay, email message to the author, May 2, 2020.

5 Ibid.

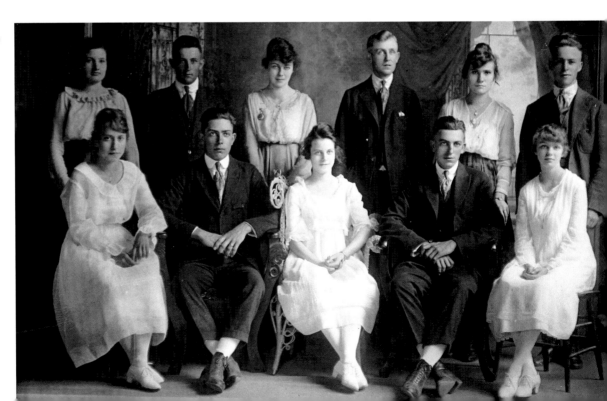

Figure 2. Bunker Hill High School Class of 1919. Clara Hatton is seated at the far left in the front row.

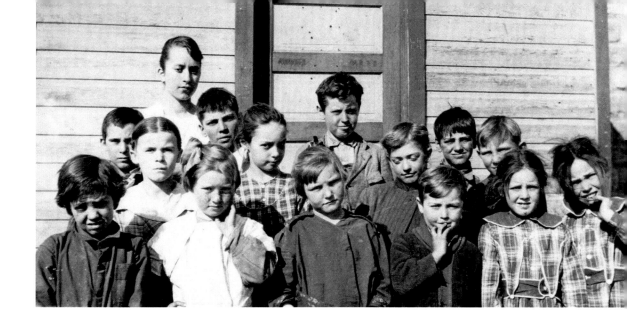

Figure 3. Clara Hatton with her students, one-room schoolhouse in Success, Kansas, ca. 1920.

that. Ora Shay recounts Apollonia's dedication to her children: "Money to buy tickets to the Lyceum, special treats, music lessons, and art supplies was earned by [Apollonia] doing the washing for 'half of Bunker Hill.'"[6] All of the Hatton children graduated from high school, which was located in Bunker Hill, a small town just to the south and the area's social and commercial center. When the time came, the family procured a room in town where Hatton could live while attending high school, a common practice of the period.[7] The artist excelled at her studies, graduating valedictorian of the Bunker Hill High School Class of 1919 (fig. 2). Following graduation, Hatton taught at a one-room country school in the area and at the elementary school in Bunker Hill, attending a teacher certificate program at

Fort Hays State College, in Hays, Kansas, during the summers of 1920 and 1921.[8] (fig. 3)

University of Kansas, Lawrence, 1922–36

In 1922, Hatton began her studies at the University of Kansas in Lawrence, enrolling in the Art Department of the university's School of Fine Arts.[9] During her time there, first as a student and then an instructor, Hatton found her artistic voice and began developing her pedagogical vision. By 1922, the KU art department was well-quipped with a faculty of five professors and capacious facilities. There were seven large studios with skylights in which students could pursue work in bookbinding, ceramics, design, drawing, jewelry and metalwork, and painting. There was also an art

6 Ibid. Additional information from Ora Hatton Shay, email message to the author, May 2, 2020.
7 Todd Goodheart (nephew of Clara Hatton), in conversation with the author, March 4, 2020.

8 Clara Hatton, "Resume" (unpublished manuscript, ca. 1975), typescript.
9 Hatton earned a BA in design (1926) and a BFA in painting (1933) from the University of Kansas.

library containing over 2,000 volumes.[10] The school offered support to students through scholarships awarded "to worthy students each fall by faculty action."[11] Hatton was a beneficiary of this largesse, receiving the 1924–25 Lathrop Bullene Memorial Scholarship her junior year.[12]

The school's primary objective and raison d'être was to train professional musicians and visual artists who could teach and practice their art in communities across Kansas. These students, the university believed, would "enrich and make more enjoyable the lives of all with whom they may come in contact."[13] The school's emphasis on the connection between art education and community surely informed Hatton's thinking about the nature of the interchange between art and community. Her creation of CSU's Occupational Therapy and Related Art program in 1944, for example, seems an embodiment of ideals to which the artist was first exposed at KU.

Hatton's mentor during her time in Lawrence was Rosemary Ketcham (1882–1940), an Ohio-born artist hired in 1920 to teach design at KU. Before coming to Kansas, Ketcham taught at Syracuse University in New York, where she was one of the founding faculty members of the school's design department. Ketcham's undergraduate course of study at Ohio Wesleyan University included traditional academic pursuits such as drawing and painting from casts, still life, life drawing and painting, and landscape, as well as handcrafts such as wood carving, china painting, tapestry painting, and decorative art. The combination of academic training and handcrafts prepared the artist well for the courses in design she was to develop and teach at Syracuse University and KU. Ketcham's embrace of the handcrafts resonated with Hatton, who, in later years, would become known for her staunchly egalitarian rejection of the notion of a hierarchy among the various modes of the visual arts.

Ketcham was an early adherent of Arthur Wesley Dow (1857–1922), the American painter, printmaker, and art educator.[14] Dow's ideas about art gained widespread currency among American art educators with the appearance of his influential book *Composition: A Series of Exercises in Art Structure for the Use of Students and Teachers*, first published in 1899. At the core of Dow's teaching was his belief that composition, the process of harmoniously arranging formal elements (line, mass, color), and not drawing, was the "fundamental process in all the fine arts."[15] Dow's thinking challenged the traditional academic emphasis on drawing from a model (a cast or landscape, for example), an approach to art education he derisively termed "imitative."[16]

Ketcham's influence on Hatton extended beyond pedagogical matters. In 1925, under Ketcham's

10 *Bulletin. School of Fine Arts. University of Kansas*, in *Bulletin of the University of Kansas* 23, no. 11 (June 1, 1922), p. 14.

11 Ibid, p. 10.

12 *Annual Catalogue, Section III, Roster of Faculty, Students, and Graduates*, in *Bulletin of the University of Kansas* 25, no. 1, part III (January 1, 1924), p. 345.

13 Ibid.

14 For information about Ketcham and Dow see Mary Ann Stankiewicz "Art Teacher Preparation at Syracuse University, the First Century" (PhD diss., Ohio State University, 1979).

15 Arthur Wesley Dow, *Composition: A Series of Exercises in Art Structure for the Use of Students and Teachers*, 9th ed. (Garden City, New York: Doubleday, Page & Company, 1916), p. 3.

16 Ibid pp. 3–4.

tutelage, Hatton made her first bookbinding in leather for a volume of collected poems by Henry Wadsworth Longfellow (p. 82).[17] Her cover design incorporates a pattern composed of pairs of blind-tooled, tendril-like spirals, punctuated with small, blind-tooled T forms and gold-tooled dots. Decorative in character, Hatton's design is purely ornamental and functions to frame and organize the cover's space, bearing little relation to the text contained within. Prosaic design aside, Hatton's first effort at bookbinding was confidently executed and shows considerable aptitude. With time, Hatton's designs for bindings became increasingly sophisticated examples of the harmonious arrangements of formal elements for which Dow advocated.

Over the course of her life and career as an artist, Hatton developed a command of an impressively wide-ranging variety of media and techniques. The polymathic artist's toolkit included painting in oil and watercolor, ceramics, metalwork and jewelry, weaving, calligraphy and lettering, bookbinding, and printmaking. Hatton's Jill-of-all-trades approach to methods and materials came naturally for the artist. Life on a Kansas farmstead demanded it. A successful farming operation required one to be her own mechanic, carpenter, plumber, and electrician, in addition to possessing the necessary agronomic skills and a penchant for hard work.

Among the media with which Hatton was proficient, she was particularly devoted to bookbinding and printmaking, both of which garnered the artist recognition throughout her career and beyond. Hatton's formative experience with printmaking, as with her bookbinding, occurred during the artist's time in Lawrence. Details of the circumstances of her introduction to printmaking are few. It appears Hatton's earliest serious foray was in Rockport, Massachusetts, at the Rockport Art Association's Summer School of Art under the instruction of American painter and printmaker Albert Thayer (1878–1965), a Boston-area artist.[18] Hatton described her etching *Alley* (1928) [not included in this exhibition] as the "very first etching I ever made. Made in Rockport."[19] *Alley* and Hatton's *Evening* (1929), an aquatint depicting a New England fishing scene, were included in the 1933 exhibition of the Society of American Etchers (formerly the Brooklyn Society of Etchers), a prestigious annual exhibition showcasing the state of American printmaking.[20]

Hatton's *Evening* (p. 38) is an accomplished exploration of aquatint, a challenging etching technique notable for its ability to describe a full range of tone. Hatton's studies for *Evening* provide a glimpse into the artist's process (pp. 39–40). The numbers inscribed on the graphite version indicate the number of minutes the corresponding areas must spend in the etching acid to achieve the desired depth of tone, per the artist's ink study for *Evening*.

17 The edition Hatton bound is Henry W. Longfellow, *Poems*, with a biographical sketch and explanatory notes by Henry Ketcham (New York: A. L. Burt, 1900). As others have noted, a typescript note in the book indicates that Hatton did the binding, her first, in 1925 with Ketcham. See Karen Jones, Terry Ann Mood, and Rutherford W. Witthus, *Bookbinding in Colorado: Creating Practical Art through Hand and Machine, 1860–1980* (Denver: Jefferson County Library Foundation, 1994), p. 13.

18 Ora Hatton Shay, "Print collection in Black Solander Box from Pam Kingsbury" (unpublished manuscript, last modified August 28, 2019), Microsoft Excel file.

19 Ibid.

20 The Society of American Etchers, *Eighteenth Annual Exhibition, National Arts Club*, November–December 1933, with Foreword by John Taylor Arms (New York: The National Arts Club, 1933), p. 14. *Alley* was catalogue number 128, *Evening* 129.

Over the course of her career, Hatton created and printed more than sixty unique images, gleaning her subjects from observations of everyday life and experiences. Views of domestic architecture, street scenes, homesteads on the Kansas prairie, industrial architecture, historic architectural monuments, and agricultural scenes provided fodder for the artist's graphic output. It is a body of work remarkable for the wide range of techniques with which she was fluent and her mastery of methods from each of the three major printmaking families: relief (woodcut, wood engraving, linoleum cut); intaglio (aquatint, etching, soft-ground etching, engraving, drypoint, mezzotint); and planographic (lithography).

Year Abroad: London and Europe, 1935–36

The artistic ideals to which Hatton most aspired have their source in two nineteenth-century European developments: the Arts and Crafts movement (1880s–1920s) and the Etching Revival (1850s–1930s). In the summer of 1935, the artist traveled abroad to study bookbinding and printmaking in London for the 1935–36 academic year. There, she had the opportunity to work with artistic descendants of both developments at two of London's most respected institutions of art education: the Central School of Arts and Crafts and the Royal College of Art. During the summer, and between terms, Hatton toured Europe, exploring the history, art, and architecture of some of the continent's major centers, including Berlin, Brussels, Hamburg, Hanover, Leipzig, Paris, Prague, Salzburg, Vienna, and Zurich.[21]

Hatton's graphic output, before and after her period of study abroad, is best understood within the context of the nineteenth-century Etching Revival. By the eighteenth century, most printmaking in the West was done in the service of reproduction (e.g., graphic reproductions of paintings, sculpture, architecture, etc.). The Etching Revival sought to recover the status printmaking enjoyed as a vehicle for original expression in the time of Rembrandt Harmenszoon van Rijn (1606–1669). American artist James Abbott McNeill Whistler (1834–1903) was among the revival's leading proponents. Etching, in particular, was viewed as among the most autographic of the graphic techniques, in part because of the loose and freely drawn character of line one can achieve, a function of the ease with which the stylus pierces the etching ground. This contrasts with engraving, which entails pushing a wood-handled, steel burin across the plate's surface to incise a crisp, unwavering line with a tapered end.

Close examination of the line work in Hatton's etching *Tree in Winter* (ca. 1932) (p. 44), a view from her kitchen window in Lawrence, reveals the etching needle's sensitivity to the artist's hand as it records even the slightest tremor. Compare this to the lines in Hatton's engraving *Kuh Wagon* (1935) (p. 45), a print she created while studying at the Royal College of Art with Malcolm Osborne (1880–1963) and Robert Austin (1895–1973), central figures in the history of twentieth-century British printmaking.[22]

21 Hatton chronicles her European sojourns in her voluminous correspondence with family members, now in the Shay family collection.

22 For information on Austin, see Campbell Dodgson, "Robert Austin, Etcher & Engraver," *Print Collector's Quarterly* 16 (1929), pp. 327-52. For information on Malcolm Osborne see Malcolm C. Salaman, "The Etchings of Malcolm Osborne,

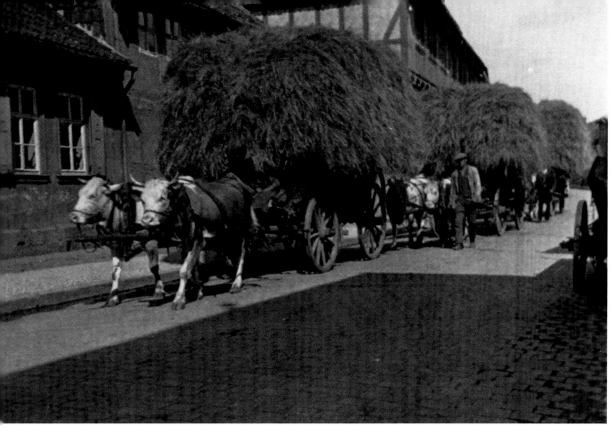

Figure 4. Cow wagons in Austria, photo by Clara Hatton, ca. 1935.

The engraved lines are, with few exceptions, linear and lack the gestural and curvilinear character of those in *Tree in Winter*. Optically, *Kuh Wagon* has an overall silvery appearance, a quality common to engravings.

The source of *Kuh Wagon* is a photograph she took for a friend while visiting Austria (fig. 4).[23] The artist delighted in observing the customs and practices associated with agriculture in Europe. Writing her brother Eddie from Vienna in July 1935, Hatton shared her observations of agriculture in Prague, commenting: "The women [in Prague] work even harder than in Germany but cow wagons and ox teams are not as common."[24] The following week, she wrote her family from Salzburg, Austria, exclaiming: "Just now two ox teams with 2 big wagon loads of hay passed by."[25] Later in life, the artist made sure to point out that "The animals in the scene are cows, not oxen."[26]

A.R.A., R.E.," *Print Collector's Quarterly* 12 (1925), pp. 285–313. For information on the Royal College of Art, see Christopher Frayling and Claire Catterall, eds., *Design of the Times: One Hundred Years of the Royal College of Art* (Shepton Beauchamp, Somerset: Richard Dennis Publications, 1996). Also see Bill North, "The Royal College of Art," *The Prints of John S. deMartelly, 1903–1979* (East Lansing: Kresge Art Museum, Michigan State University, 1997): pp. 3–4.

23 Shay, "Print collection."

24 Clara Hatton to Edward Hatton, July 21, 1935, Shay family collection.

25 Clara Hatton to Apollonia Hatton, July 28, 1935, Shay family collection.

26 Shay, "Print collection."

Engraving held particular appeal for Hatton, who wrote her sister Edith in November 1935, explaining: "My engraving teacher to-day asked me if it were necessary for me to go back in January. He said it was a shame not to stay on a while longer as I was only starting."[27] Later that month, in a letter to her brother Eddie, the artist reported: "The copper engraving is what I am enjoying most and what I get best." Hatton's study with Osborne and Austin was remarkably fruitful, resulting in examples of most of the intaglio processes: aquatint, etching, engraving [pp. 45, 46], drypoint, and mezzotint [p. 50].

Hatton studied wood engraving with Noel Rooke (1881–1953) and John Farleigh (1900–1965) at the Central School of Arts and Crafts, an institution steeped in the ethos and ideals of the Arts and Crafts movement and the philosophies of William Morris (1834–1896) and John Ruskin (1819–1900). Her *Shambles Restaurant* (1935) (p. 47), made under Rooke's direction, is a tour de force of wood engraving. In 1935 the print entered the permanent collection of the Library of Congress when it was acquired as one of that year's selections by the jury of the prestigious Pennell Fund.[28] Wood engraving is a relief process in which the design is engraved with a burin on the end grain of a block of hardwood. The end grain's density allows for very fine and exacting line work. Hatton's handling of the technique is breathtaking, rendering space, light, and material with an arabesque of intricate,

finely engraved lines. The artist's signature on the impression in this exhibition includes her middle initial "A," an indication it was printed in Salina, Kansas, sometime after 1970.[29]

Hatton also studied bookbinding at the Central School of Arts and Crafts. Among her teachers was Sydney "Sandy" Cockerell, son and former student of Douglas Cockerell (1870–1945), a doyen of early twentieth-century British bookbinding.[30] The younger Cockerell taught Hatton how to make marbled paper for use as decorative endsheets. She used examples of Cockerell's own marbled paper in several of the bindings included in this exhibition [pp. 78, 81, and 83]. Cockerell also taught Hatton how to make her own tools for finishing her leather bindings, a practice she continued throughout her life. And, notably, Cockerell arranged for Hatton to purchase a rare set of handle letters in Doves Type, the distinctive typeface of the Doves Press, one of the most influential Arts and Crafts small presses of the early twentieth century (pp. 74–75). Hatton often used the Doves handle letters to decorate her own bindings, for example, the title on the covers and spine of her binding for *The Book of Ruth* (p. 80), which she started work on while at the Central School of Arts and Crafts. Hatton scribed and illuminated the pages while studying calligraphy at the school with Lawrence Christie and Rosemary Ratcliffe. She bound the book after returning to Kansas. The artist expressed her enthusiasm for

27 Clara Hatton to Edith Hatton, November 1, 1935, Shay family collection.

28 Karen F. Beall, *American Prints in the Library of Congress: A Catalog of the Collection*, with Introduction by Alan Fern and Foreword by Carl Zigrosser (Baltimore: The Johns Hopkins Press, 1970), p. 202.

29 After 1970, Floyd Gibson, an art teacher at Salina Central High School, Salina, Kansas, reprinted a number of Hatton's plates and blocks under her direction.

Information about Hatton's study with Sandy Cockerell taken from Karen Jones, "Clara Anna Hatton Biography" (unpublished manuscript, prepared for the Guild of Book Workers' centennial convention in New York City, December 2006).

the project to her sister Edith in November 1935, writing:

> In fact I am working my head off and I am planning to work even harder as I am starting to make a 'Book of Ruth.' Letter it! Decorate it! And then bind it. This mostly at home in the evenings and odd times.[31]

Colorado State University, 1936–66

When Hatton arrived on the campus of Colorado State College of Agriculture and Mechanic Arts (now Colorado State University) in Fort Collins, she was in full command of her artistic abilities, having recently devoted a full year to honing her craft, free from the demands of teaching. In her new position, Hatton's administrative and teaching loads were much too heavy to accommodate the kind of dedicated focus on her practice she enjoyed in London. Though she continued to create work across a broad range of media throughout the rest of her life, the level of Hatton's studio production diminished as her time as an administrator wore on. Still, she took great pleasure in making art. The artist loved, for example, spending time outdoors sketching and painting the Colorado landscape. She was also fond of capturing the likenesses of nieces and nephews in quick sketches or more considered portrait paintings. At her Fort Collins home on 416 South Grant Avenue, the artist often retreated to her backyard studio, a converted chicken coop, to work on her ceramics away from the demands of academe.

Following the death of Hatton's father in 1938, the artist's mother Apollonia moved to Fort Collins to take up residence with her daughter—a mutually beneficial arrangement.

Hatton took a sabbatical during the 1944–45 academic year to attend the storied Cranbrook Academy of Art in Bloomfield Hills, Michigan, where she earned an MFA. Hatton's thesis, "Design and the Graphic Arts," presents a history of printmaking and the graphic arts and is illustrated with examples of her printmaking, typography, and design.[32]

Homecoming: Salina, Kansas, 1970–91

Clara Hatton's story begins and ends in Kansas.

In 1970, four years after her retirement, Hatton and her mother moved to Salina, Kansas, where the artist's brother Lloyd lived. After the move, much of Hatton's energy was given to tending to Apollonia, who, by that time, was in her nineties and in failing health. Still, Hatton managed to maintain a studio in her modest house and find time for making and sharing art. She was active in the Salina arts community, participating in benefit art auctions, teaching workshops, and serving as the president of the Salina Society of Art, among other activities.

Hatton's retirement years were also a time for recognition and reflection. In 1975, the Department of Design in the School of Fine Arts at the University

31 Clara Hatton to Edith Hatton, November 1, 1935, Shay family collection.

32 Clara Hatton, "Design and the Graphic Arts" (MFA thesis, Cranbrook Academy of Art, May 1945); see pp. 58–59 for illustrated examples.

of Kansas and the school's alumni association honored Hatton as a Distinguished Craftsman for her outstanding professional achievement. The Guild of Book Workers, an organization to which Hatton had belonged since 1961, honored the artist in 1981 by including one of her bindings, *The Book of Kells*, in the group's seventy-fifth anniversary exhibition, which premiered at New York City's legendary Grolier Club before traveling to venues in four other major American cities.[33] The guild honored Hatton posthumously with the inclusion of the artist's binding and calligraphy for *The Book of Ruth* in the organization's centennial exhibition in New York City in 2006. Hatton's greatest honor came in 1975 with the dedication of the CSU art department's new Clara Hatton Gallery in Fort Collins.

On June 27, 1991, Clara Hatton passed away after suffering a heart attack at home in Salina while tending to her garden. She left this world doing what she cared about most—working with her hands in search of beauty and sustenance. It was an apt and poetic conclusion to a life and art well done. ❖

Bill North
Director of the Clara Hatton Center,
Salina, Kansas

33 The other venues were Missouri Botanical Garden, St. Louis, Missouri; Humanities Research Center, University of Texas, Austin; Cecil H. Green Library, Stanford University, Stanford, California; and the Newberry Library, Chicago, Illinois.

A History of the Art Department under Clara Hatton

When Clara Hatton arrived at the Colorado State College of Agriculture & Mechanic Arts in 1936, art courses were a minor component of the Division of Home Economics, one of five divisions that composed the state college in Fort Collins, and the primary source of degrees for women. But over the next three decades, Hatton built an art program that became its own department within the College of Science and Arts (today in the College of Liberal Arts), with degrees serving hundreds of students each year. This essay charts Hatton's formidable efforts to establish an art department in an agricultural college, forming what we know today as the Department of Art & Art History at Colorado State University.

Before Clara: Art and land-grant colleges

Art had little place in the curriculum of the original Colorado Agricultural College in Fort Collins, founded in 1870 as part the land-grant college movement that focused on the "liberal and practical education of the industrial classes."[1]

The 1862 Morrill Act provided states with 30,000 acres of land per senator and representative, allowing the sale of that land to raise funds for an agricultural college. These land-grant colleges were hailed as a "distinctly American" approach to higher education, departing from the university's traditional role of training the elite for positions in the clergy, professoriate, and other "sedentary roles," and focusing instead on educating the farmers and engineers who would develop the massive land base of the United States.[2] (Of course, what was also "distinctly American" about this approach was the fact that the land sold to create the land-grant colleges was appropriated, often through force, from Indigenous peoples. In Colorado, for example, nearly half of the "public land" used to endow the Colorado Agricultural College came from tracts that had been promised to Cheyenne and Arapaho peoples, but which were "made available" less than one year after the 1864 Sand Creek Massacre that brutally drove Indigenous people off those lands.[3])

Agriculture and the mechanic arts were the subjects thought most useful for male students in Fort Collins; "domestic economy," as home economics

1 The frontispieces to the Colorado Agricultural College bulletins frequently described land-grant institutions in these terms. One example from the 1924–25 catalogue stated that "the land-grant colleges are the most interesting of all American educational institutions. They were founded to realize a demand for an American type of training, which began with the landing of the Pilgrims in America and which has continued with increasing force down to the present day [It was] an insistent demand for a type of training suited to the pioneer spirit of America, and adapted to release the creative energy of America in productive work" (Frontispiece, *Colorado Agricultural College Bulletin*, 1924–25).

2 Morril act quoted in Edward Danforth Eddy Jr., *Colleges for Our Land and Time: The Land-Grant Idea in American Education* (New York: Harper & Brothers, 1956), xiii.

3 Robert Lee and Tristan Ahtone, "Land Grab Universities: Expropriated Indigenous Land is the Foundation of the Land-Grant University System," *High Country News*, March 30, 2020. Online edition: https://www.hcn.org/issues/52.4/indigenous-affairs-education-land-grab-universities

Figure 1. Simon Guggenheim Hall of Household Arts on Laurel Street in 1937. The Guggenheim housed the Division of Home Economics and all art courses until the 1940s. University Historic Photographic Collection, CSU Archives and Special Collections.

was called when it was established in 1894, was the only degree for women. Yet this emphasis on a practical education did not deny the liberal—or the fine—arts altogether. Elijah E. Edwards, the first president of Colorado Agricultural College, stated that "a one-sided education produces an un-symmetrical man. By a liberal education, increased power and versatility is gained."[4] The earliest programs of instruction at the Colorado Agricultural College required courses in English composition, rhetoric, U.S. history, and drawing, the latter which included "lessons in free hand, industrial and perspective" methods.[5]

The Division of Home Economics followed the state college's lead in prioritizing a practical education mixed with a few courses in the liberal and applied arts. Emerging from the earliest "Ladies' Course" in 1891, the Department of Domestic Economy was established in 1894 and morphed into Domestic Science by 1908. By 1910, the same year that the Guggenheim Hall of Household Arts was being constructed on Laurel Street to house it (fig. 1), the newly named Division of Home Economics had declared its mandate "to fit young women to be good housekeepers, wives and mothers, and to teach them how to keep the house so as to

4 Quoted in Rachel Gaisford, "Beyond the A & the M: College of Liberal Arts," CSU Life: *Faculty and Staff*, March 2020, p. 6.

5 *Colorado Agricultural College Bulletin*, 1879, p. 3. Unless noted otherwise, all

bulletins and course catalogues cited in this essay are in the Archives and Special Collections of Colorado State University.

make it a place of health, comfort and happiness."[6] Women pursuing the Bachelor of Science degree in Home Economics took courses in nutrition, food preservation, animal husbandry, and nursing, as well as courses in dressmaking and interior design, the latter which gave rise to classes in applied design. The 1925 Colorado Agricultural College catalogue billed its design courses as the practical application of theory, or "the carrying over of design principles to dress and to house decoration."[7] By 1930, however, the division reasoned that homemaking was "much more than a matter of materials and skills," and more students were urged to take courses in literature, modern languages and the sciences.[8] Applied art classes also grew in the 1920s and 1930s, opening the door for Clara Hatton and her expanded curriculum of art.

Contrary to an oft-repeated claim, Hatton was not the first instructor to teach art classes in the Division of Home Economics. Nellie M. Killgore, a home-grown Aggie who had graduated a few years earlier with a BS in Home Economics, appears in the 1907–08 course catalogue teaching "Basketry" and "Nature and Art 1 & 2," the latter which was described as "drawing and painting from Nature, watercolors and oil, indoors and outdoors."[9] By 1919, Killgore had added a course in Applied Design, wherein "practical designs [are] worked out and applied to lessons in dressmaking and art needle work, as well as the ornamental features of home decoration."[10] A third course in advanced applied design rounded out the art courses, which were still a minority among courses like Diatetics, Buttermaking and Milk Separation, Poultry Husbandry, and Eugenics.

By 1921, Killgore was replaced by Bertha A. Most, a graduate of the Pratt Institute of Fine and Applied Arts in New York, who taught Killgore's classes and added others, including the first History of Art course in 1925. By the late 1920s, the Division of Home Economics offered courses in Furniture and Interior Design alongside courses in Dressmaking, Costume Design, Textiles, Investigation in Cookery, Child Welfare, and Home Care of the Sick.[11] In 1933, Most offered a new course, "Free Hand Drawing and Perspective," which provided "a foundation for later specialization in art schools"—the first time an art career had been highlighted as a separate path from home economics.[12] This distinction deepened the following year, when the Division of Home Economics named "related art" as one of four formal sequences that students could pursue within the BS in Home Economics.[13]

The late 1930s

It was at this moment that Dean Inga M.K. Allison hired Clara Hatton to join the Division of Home Economics. In 1936, one year after the Colorado Agricultural College was renamed the Colorado State College of Agriculture & Mechanic Arts,

6 *Colorado Agricultural College Bulletin*, 1908–09, p. 52.
7 *Colorado Agricultural College Bulletin*, 1925–26, p. 39.
8 *Colorado Agricultural College Bulletin*, 1929–30, p. 39.
9 *Colorado Agricultural College Bulletin*, 1907–08, p. 159.

10 *Colorado Agricultural College Bulletin*, 1919–20, p. 55.
11 *Colorado Agricultural College Bulletin*, 1929–30, pp. 40–41.
12 *Colorado Agricultural College Bulletin*, 1933–34, p. 103.
13 The 1934–35 catalogue noted that "A choice may be made from four sequences at present open to undergraduate students: Teaching, related art, clothing and textiles, and nutrition." *Colorado State College Bulletin*, 1934–35, p. 39.

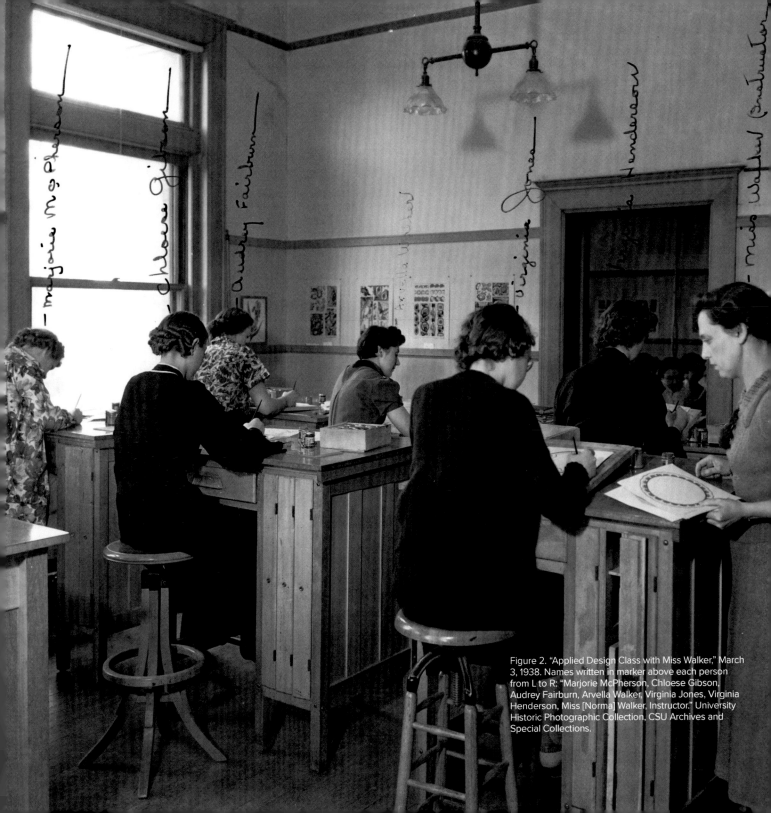

Figure 2. "Applied Design Class with Miss Walker," March 3, 1938. Names written in marker above each person from L to R: "Marjorie McPherson, Chloese Gibson, Audrey Fairburn, Arvella Walker, Virginia Jones, Virginia Henderson, Miss [Norma] Walker, Instructor." University Historic Photographic Collection, CSU Archives and Special Collections.

Hatton joined the Fort Collins faculty, inheriting the courses that Bertha Most had taught.[14] Hatton immediately began expanding the art curriculum, adding a new course in "Handcrafts" that she described in the 1937 catalogue as the "application of fundamental art knowledge through the making of block prints, stencils, embroidery, batik, tooled leather and other craft problems." Hatton also split the art history course into two semesters, teaching Western art from ancient times to the Renaissance in one semester and Western art from the Renaissance to the present in the other.[15]

In 1937, Hatton was joined by Norma Walker, whom Dean Allison hired as an "assistant" before she became a tenure-track assistant professor in 1941. A fellow alumna of the University of Kansas, Walker specialized in weaving and took over textiles and applied design courses (fig. 2), freeing Hatton to develop other art courses. The two women were the only faculty dedicated to "art and handcraft" in Home Economics throughout the years of World War II.

The 1940s

During the war, art courses in Fort Collins became tied to occupational therapy, part of a widespread movement to use art to rehabilitate veterans from the mental and physical costs of combat. In 1944, the same year that Colorado State College of Agriculture and Mechanic Arts changed its official name to Colorado A&M, Hatton established a new course of study in "Related Art and Occupational Therapy," which required students to add one year of "practical experience" in a hospital to the four-year degree in Home Economics.[16] Hatton seems to have been responsible for establishing it in Fort Collins, even making a trip to Washington, DC to lobby for funding.[17]

Thanks in part to this new funding, and to the end of the war, Hatton managed to add several new courses to the catalogue in 1945-46. These included Bookbinding, Metalwork & Jewelry, and Ceramics, the latter which she fought for despite a remark from the dean: "Don't you think it [pottery] is going to go out of style?"[18] Hatton was also inclusive when it came to art history, adding "Oriental Art" to the survey courses in 1948, and soon requiring a third semester in the art history sequence in order to cover "African and American Indian and Mexican art."[19] This ecumenical approach to art history and art making—championing the "handcrafts" as much as the "fine arts," and including non-Western art history long before many universities required it—was typical of Hatton. Jack Curfman, whom Hatton hired as a part-time instructor in 1946, remembered

14 Clara Hatton did not appear in the course catalogue for the 1936–37 academic year, probably because her contract was not yet finalized when the catalogue was printed in spring of 1936. But she appears in the 1937–38 catalogue teaching most of the courses formerly assigned to Bertha Most (who was no longer listed on the faculty), along with the new courses in Handcrafts that Hatton developed.

15 *Colorado State College of Agriculture and Mechanic Arts Bulletin*, 1937–38, p. 87.

16 *Colorado State College of Agriculture and Mechanic Arts Bulletin*, 1944–45, pp. 80–81.

17 Elizabeth Dyar Gifford, who became Dean of Home Economics, credited Hatton for catalyzing the Occupational Therapy program in Fort Collins.
See James E. Hansen II, *Democracy's College in the Centennial State: A History of Colorado State University* (Fort Collins: Colorado State University, 1977), p. 356.

18 Quoted in Betty Woodworth, "Do you remember CSU 'Biltmore'?" *Coloradoan*, October 1975, n.p.

19 The 1948 course changes included "oriental and savage art," while the three-semester survey was added by 1951–52 (*Colorado Agricultural and Mechanical College Bulletin*, 1951–52, p. 144).

that "Clara didn't believe in a hierarchy of media; the printmaker, the bookbinder, the painter, were all equal."[20] This philosophy would conflict with the hierarchies of modernism that took hold of American universities after the war, when abstract painting and sculpture reigned supreme, but Hatton maintained her commitment to her Arts & Crafts training throughout her career.

To accommodate her growing number of classes, Hatton had to find space outside the Guggenheim Building. In 1944, Hatton obtained the use of Spruce Hall, originally built in 1881 as a dormitory near College Avenue; she converted its south wing into a weaving studio and its north wing into a ceramics studio. There was no money available for a kiln, but she found an Army surplus kiln in Denver and hauled it back to Fort Collins.[21] By 1949, home furnishings and a metals studio were housed on the second floor of the "Biltmore," a derisive nickname for a run-down building that had been used as a dormitory during the war. Classrooms were now spread across campus, with instructors trundling slide projectors and other equipment from one building to another. But there was also more demand for art classes, and more justification for Hatton's vision to establish an art department in Fort Collins.

The 1950s

The 1950s was an important decade in the history of the art department. William Morgan, elected president in 1949 to what became Colorado Agricultural and Mechanical College in 1950, sought to transform the agricultural college into a full-fledged university with more courses in the liberal arts and social sciences; he succeeded in doing so in 1957, when the institution was renamed Colorado State University. This change was accompanied by a larger reorganization of divisions into schools and courses of study into departments, so that the School of Home Economics now housed the departments of Related Art, Occupational Therapy, and General Home Economics, among others. There was also more support for the fine arts: Elizabeth Dyar, the acting dean of the School of Home Economics, was a strong supporter of the arts, as was William Morgan's wife, Lilla B. Morgan, who wanted Fort Collins to be home to more than a "cow college."[22]

Hatton took advantage of this new climate, working to make art its own degree program. In 1949, "Related Art" had become its own course of study in the Division of Home Economics, separate from Occupational Therapy; by 1950 it was officially listed as its own Department in the School of Home Economics, with Hatton as its head. The 1950 catalogue advertised the Related Art sequence "for those students interested especially in making the home a more livable and beautiful place. Although the basic course of study is the same as in other Home Economics options, this plan allows for more courses in the field of creative and related art."[23]

20 Jack Curfman in recorded interview with Ora Shay, November 19, 2013, Fort Collins, Colorado.

21 Betty Woodworth, "Do you remember CSU 'Biltmore'?" *Coloradoan*, October 1975, n.p.

22 Quoted in Nik Olsen, "Lilla B. Morgan, Advocate for the Arts," Office of the President, Colorado State University https://president.colostate.edu/lilla-b-morgan-advocate-for-the-arts/

23 "Course of Study in Related Art," *Colorado Agricultural and Mechanical College Catalogue*, 1950–51, p. 129.

In 1953, Hatton managed to drop the "Related" from her department's name altogether and to make the Department of Art its own official entity within the School of Home Economics. The new name reflected art as a legitimate field of study, un-"related" to any application in home economics. Today, the Department of Art & Art History still recognizes 1953 as its official founding.

The 1950s also saw a burst in hiring of art faculty. In 1950, Hatton found a full-time position in interior design for the legendary John ("Jack") Curfman, an Aggie who had been her student.[24] The first male faculty member hired in Home Economics, Curfman went on to a fifty-one-year career at CSU, first in Home Economics, then in Art, and still later in Design and Merchandising. In 1953, Hatton hired

William Imel to teach design and drawing classes. In 1957, Hatton hired painter David Dietemann from the University of Illinois; in 1958, she hired John Sorbie, also from the University of Illinois, to teach graphic design. With Norma Walker teaching weaving, and Karen Askren teaching art history and drawing, the art faculty now numbered six (fig. 3). The new hires allowed Hatton to delegate classes to other instructors and focus on the administrative work of the department. She once admitted, however, "I was sorry to relinquish any of them [art courses] to other teachers."[25]

With more faculty teaching more classes, Hatton again had to find more space for art on campus. She converted rooms to studios in the basement of Old Main, the iconic first building on the Fort Collins

24 Curfman began as a part-time faculty member in 1946, but it was not until 1950 that a tenure-track position opened. See Libby James, "Extra," *Fort Collins Review*, September 23, 1979.

25 Hatton quoted in Betty Woodworth, "Do you remember CSU 'Biltmore'?" *Coloradoan*, October 1975, n.p.

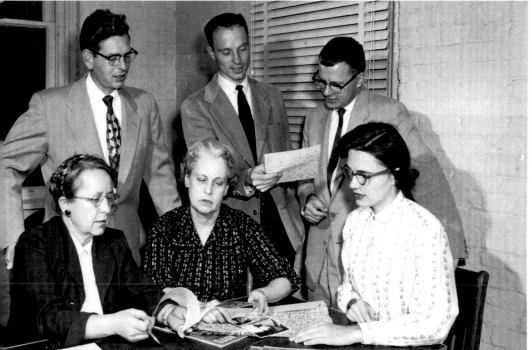

Figure 3. Department of Art faculty, June 25, 1958. Standing L-R: William Imel, Dave Dietemann, Jack Curfman. Seated: Clara Hatton, Norma Walker, Karen Askren. Photo courtesy of Ora Shay.

campus that had been built in 1879. In 1957, Hatton secured offices and classrooms in the newly minted "Arts Building," formerly the Mechanical Engineering Building from 1883, which was next door to the Guggenheim on Laurel Street. The first CSU Art Gallery was housed in the Arts Building, and the faculty began to work for a Fine Arts series to bring visiting artists to CSU. With little money available from the administration, the faculty took to producing their own series of fundraising entertainment known as the "Faculty Follies." The Art Department Ballet was the hit of the show, featuring several faculty members in tutus—including Hatton, who was not too proud to perform to raise money for the arts (fig. 4).

The 1960s

But Hatton was still not content with being housed in

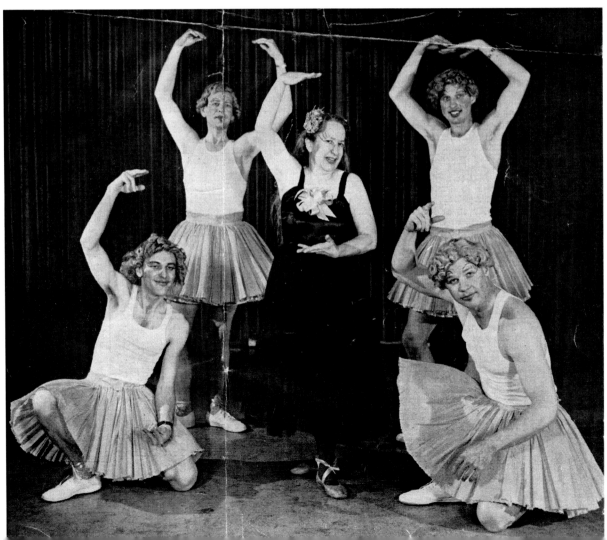

Figure 4. The Art Department Ballet brought down the house at the "Faculty Follies" show in Spring 1959. Standing left to right: Bill Imel, Clara Hatton, Dave Dietemann; kneeling: Don Covington and John Sorbie. Photo courtesy of Ora Shay; originally published in the *Collegian*.

the School of Home Economics. Dave Dietemann remembered that Hatton felt that "home economics was a service department only, with no major [dedicated to art]. Clara engineered a major in art in the *humanities*."[26] There is little documentation of how Hatton actually strategized this move, but the times were in her favor. President William Morgan continued to champion the liberal and fine arts as Colorado State University transitioned from its former reputation as an agricultural college to a broad-spectrum university; at the national level as well, the Truman Commission on Higher Education had called for increasing attention to humanities and social sciences.[27] In 1962, the Department of Art left Home Economics and moved to the College of Science & Arts, where it began granting students a Bachelor of Arts degree, rather than the Bachelor of Science.

At first, there were challenges to being in the liberal arts. Hatton laughed in a later interview when she remembered appealing to her new dean for money: "The dean said, 'There is no money budgeted for the art department, but I'll give you five dollars.'"[28] Eventually this budget was increased, but in the meantime Hatton resorted to her usual resourcefulness in scrounging up used equipment and supplies. By 1964 and 1965, Hatton was able to hire *nine* new faculty members to serve her growing department. Classes were still spread out in various buildings, including Old Main, Spruce Hall, the Arts Building, and the Biltmore, among others. However, in 1965, the main art offices moved into the newly completed Humanities Building (now known as Eddy Hall) at the center of campus. The Department of Art was now physically housed with the humanities, just as Hatton had long envisioned it should be.

For all of her progressive maneuvers, however, it should be noted that Hatton was not always the most progressive administrator. Although she was a woman and department chair who had fought for respect at CSU, Hatton frequently favored men over women in her own hiring and promotion practices, and there are stories of her favoring male students as well. Dave Yust remembered being hired as a painting professor in 1965 after Hatton's first choice, an applicant with the first name "Terry," turned out to be a woman rather than a man.[29] A former student remembered receiving a significantly lower grade than her male classmates for an assignment in Hatton's lettering class—even though the male students had copied the female student's alphabet! These anecdotes do not square with the memories of women in Hatton's own family, who recall Hatton supporting their creative pursuits in the middle of their own responsibilities as homemakers. (One of Hatton's nieces, for example, remembered that after she had given birth to her third child, Hatton asked her what she wanted to do for herself "now that she had had her family" and promptly bought her a bassoon.)[30]

26 Dave and Pat Dietemann in interview with Emily Moore and Bill North, November 15, 2019, Fort Collins.

27 Rachel Gaisford, "Beyond the A & the M: College of Liberal Arts," *CSU Life*, March 2020, p. 6.

28 Hatton quoted in Betty Woodworth, "Do you remember CSU 'Biltmore'?"

29 Dave and Joan Yust interview with Emily Moore and Bill North, November 13, 2019, Café de Vino, Fort Collins.

30 Personal communication from Ora Shay, January 18, 2020.

Hatton also had some conservative tendencies in her approach to art, which brought her into increasing conflict with her students and faculty in the 1960s. She did not allow nude models in figure drawing classes until the 1960s, requiring models to wear leotards long after other art departments in Colorado had dropped them. She resisted the use of acrylic paint in the art department until the 1960s, more than a decade after the medium had become popular. Most controversially, she was wary of abstraction during the very period that Abstract Expressionism dominated not one but two generations of American art. Dave Dietemann recalled that Hatton was staunchly opposed to him teaching abstract art. "She made it clear before I got here that there would be no abstraction here, and she made it clear again when I arrived," Dietemann said.[31] However, after two years of keeping his promise not to teach abstract art at CSU, Dietemann quietly began allowing his students to do abstract work, and one of his students' paintings won Best in Show in a national college art show in 1959. To her credit, Hatton complimented the student—and Dietemann—for their work, and she seems to have accepted more abstraction in the department in her last six years as chair.

But the rift between Hatton's applied art focus and the fine art focus of an increasing number of American art programs deepened in the 1960s, leading to a painful end to Hatton's thirty-year career at CSU. Jack Curfman recalled an "awful" meeting in the fall of 1965, when the dean asked Hatton to leave the following summer, one year before she had planned to retire. (Hatton would turn 65 in October 1966 and had wanted to retire the following summer.) Despite several faculty members advocating for Hatton to stay for her final year, her last day in the CSU Art Department was June 30, 1966. Hatton and her mother moved back to Kansas a few years later, changing her original plan to remain in Fort Collins.

Despite this acrimonious end, however, no one denied the fact that it had been Hatton's life's work to establish the art department at CSU, and efforts began to honor her legacy. Under the leadership of Perry Ragouzis, who moved to Fort Collins to become the new chair in 1966, the art department began lobbying for its own building that could unite the studios and classrooms scattered across campus—and house an art gallery named in Hatton's honor. This effort was made more urgent by the 1970 burning of Old Main, which left the department scrambling once again for studio and classroom space.[32] Ragouzis assembled a Citizens' Committee to raise money and support for the new building, drawing on the help of parents of art students

31 Dave and Pat Dietemann in interview with Emily Moore and Bill North, November 15, 2019, Fort Collins.

32 The infamous fire that destroyed Old Main is often attributed to the social foment of Vietnam and Civil Rights protests on campus; according to Jack Curfman, however, it was actually the act of an art student. It seems that a male student was desperate to evade the strict deadlines of Norma Walker's weaving class in the basement of Old Main—Walker was said to cut weavings off the looms at the stroke of the deadline, whether or not the weaver had finished—so he built a small fire to set off the smoke alarm and excuse the need to "abandon" his work. The fire quickly got out of hand, however, and ended up destroying the entire building, an icon of Fort Collins's campus and a center for many art classes during Hatton's time. Jack Curfman in recorded interview with Ora Shay, November 27, 2013; again in interview with Bill North and Emily Moore, November 19, 2019.

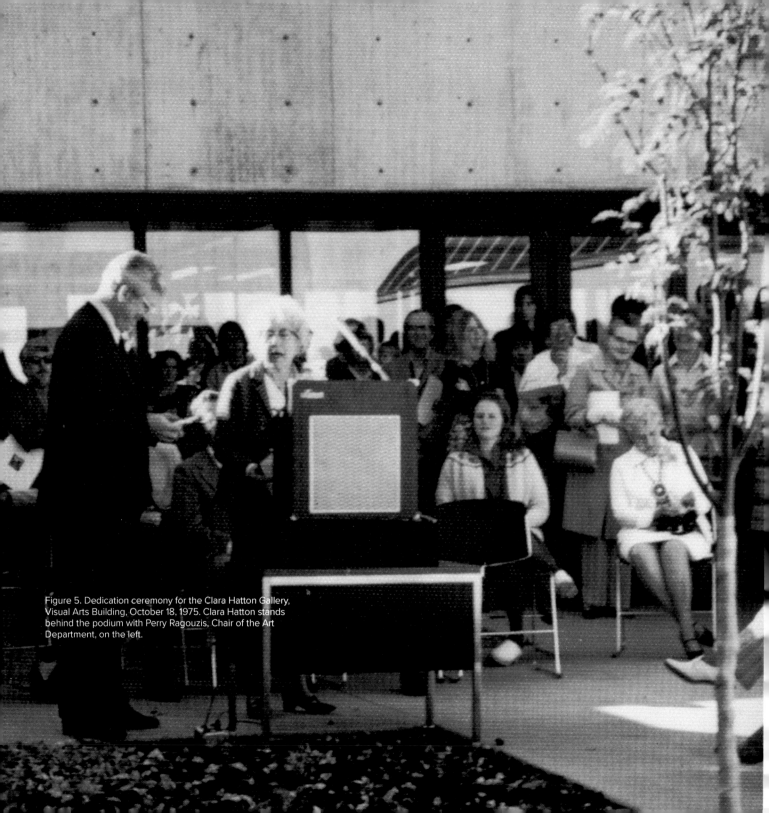

Figure 5. Dedication ceremony for the Clara Hatton Gallery, Visual Arts Building, October 18, 1975. Clara Hatton stands behind the podium with Perry Ragouzis, Chair of the Art Department, on the left.

and community members, many of whom had known Clara Hatton. When the new Visual Arts Building opened on campus in 1975, Hatton was invited back from Kansas as a guest of honor, and she participated in the naming ceremony of the Clara Hatton Gallery at the center of the building (fig. 5). In 1979, she returned to Fort Collins again for a solo retrospective exhibition of her art in the new Directions Gallery in the Visual Arts Building. Whatever wounds had opened in the 1960s must have healed, to some degree, a decade later.

Today, the Department of Art & Art History recognizes Hatton for her vision and tireless efforts to build a robust art program at Colorado State University. In his book *Democracy's University*, Jim Hansen noted that "a colleague described Hatton as single-handedly responsible for elevating the study of art to respectable academic status during CSU's emergence as a university."[33] Jack Curfman recalled that Hatton "was a wonderful one with her foot. If she could get her foot in, she would... and then open the door, whatever she had to do.... We wouldn't even really have an art department if Clara hadn't started and kept adding courses and building it up that way before it was ever an art department."[34] Despite the many challenges she faced in building an art program in Fort Collins, Hatton seems to have relished the work to achieve her vision.

In a 1979 interview, during what turned out to be her last visit to campus, Hatton was asked if she resented the energy she put into the art department when she could have devoted more time to her art. "I have no regrets," she replied. "I was more interested in developing the department."[35] ❖

Emily Moore
Associate Curator of North American Art,
Gregory Allicar Museum of Art, and
Associate Professor of Art History,
Department of Art and Art History,
Colorado State University

33 James E. Hansen II, *Democracy's University: A History of Colorado State University*, 1970–2003, p. 232

34 Jack Curfman in recorded interview with Ora Shay, November 27, 2013, Fort Collins.

35 Libby James, "Extra," *Fort Collins Review*, September 23, 1979, n.p.

Chronology

1901 Clara Anna Hatton born October 19, near Bunker Hill, Kansas.

1919 Graduates valedictorian of Bunker Hill High School, Bunker Hill, Kansas.

1920–21 Teaches at one-room school in Success, Kansas, and the elementary school in Bunker Hill, Kansas. Attended teacher certificate program at Fort Hays State College, Hays, Kansas.

1922 Enrolls in the Art Department, School of Fine Arts, University of Kansas, Lawrence.

1925–36 Instructor, Art Department, School of Fine Arts, University of Kansas.

1926 BA in design, Art Department, School of Fine Arts, University of Kansas.

1933 BFA in painting, Art Department, School of Fine Arts, University of Kansas.

1935–36 Tours Europe and studies in London at the Central School of Arts and Crafts and the Royal College of Art.

1936 Hired to teach art, Division of Home Economics, Colorado State College of Agriculture and Mechanic Arts (now Colorado State University) in Fort Collins, Colorado.

1944 Establishes course of study in Related Art and Occupational Therapy.

1945 MFA, Cranbrook Academy of Art, Bloomfield Hills, Michigan. *Design and the Graphic Arts* (MFA thesis).

1949–50 Develops Department of Related Art, School of Home Economics. Becomes department head.

1953 Department of Related Art becomes Department of Art, School of Home Economics.

1962 Department of Art moves from School of Home Economics to College of Science and Arts and begins offering BA degree.

1966 Retires from Colorado State University, June 30.

1970 Moves to Salina, Kansas.

1975 Honored as a Distinguished Craftsman, Department of Design, School of Fine Arts, University of Kansas. Dedication of Clara A. Hatton Gallery, Department of Art, Colorado State University.

1981 Binding for *The Book of Kells* included in the Guild of Book Workers seventy-fifth anniversary exhibition.

1991 Passes away June 27, Salina, Kansas.

2006 Binding and calligraphy for *The Book of Ruth* included in the Guild of Book Workers centennial exhibition.

Works in the Exhibition

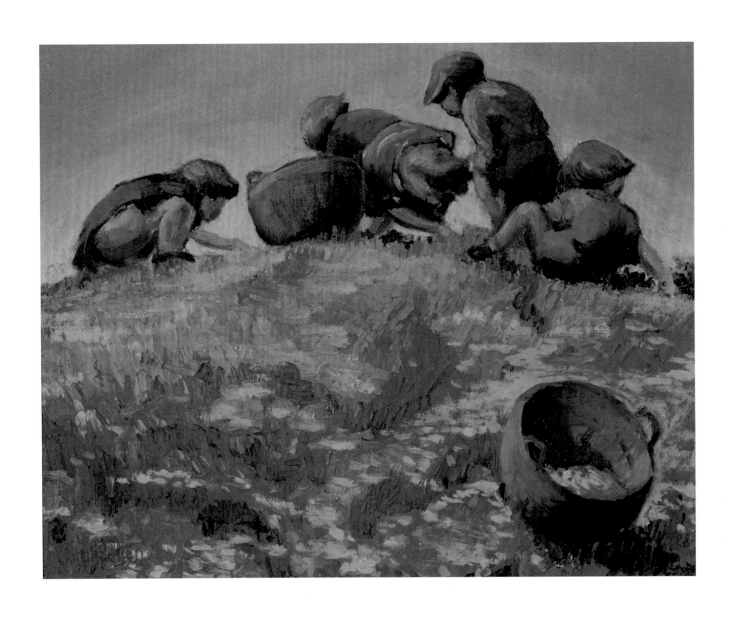

Picking Dandelions, 1928
Oil on paperboard

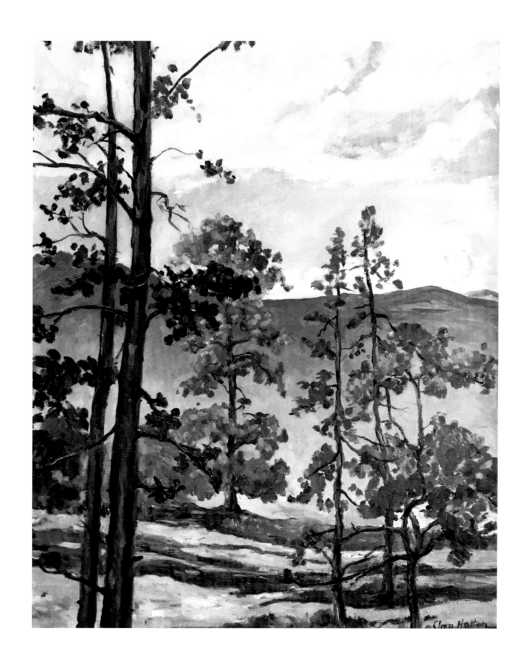

Pine and Aspens, 1930s
Oil on linen over paperboard

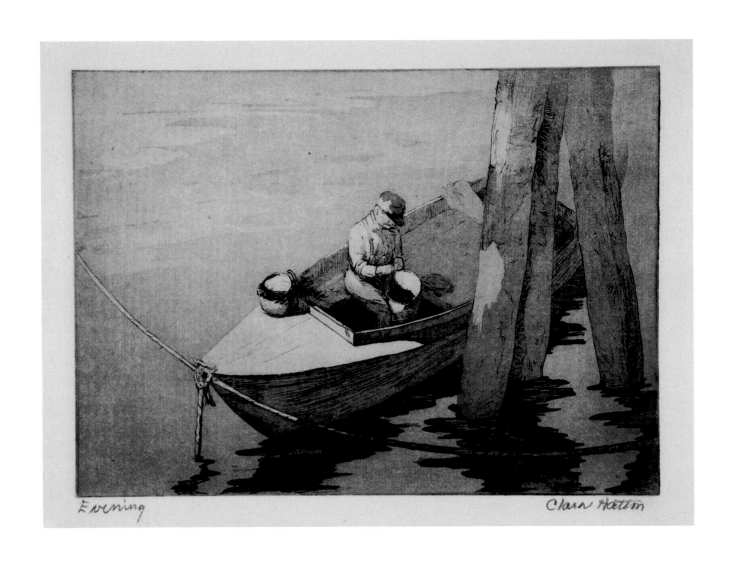

Evening, 1929
Aquatint with etching and
drypoint on laid paper

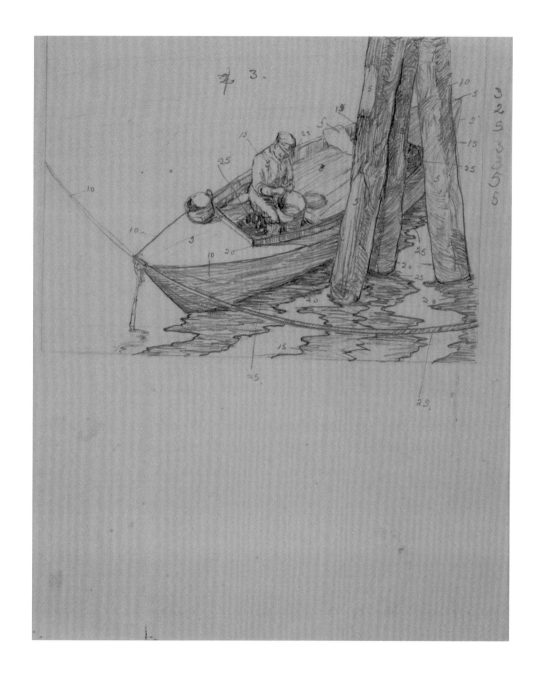

Study for *Evening*, ca. 1929
Graphite on wove paper

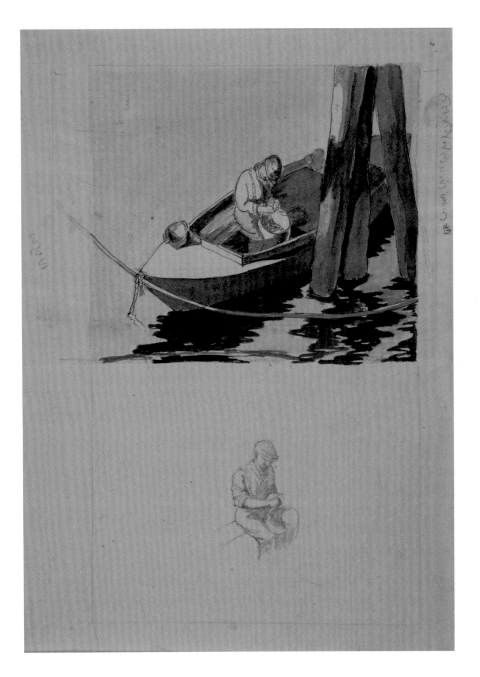

Study for *Evening*, 1929
Ink with graphite on wove paper

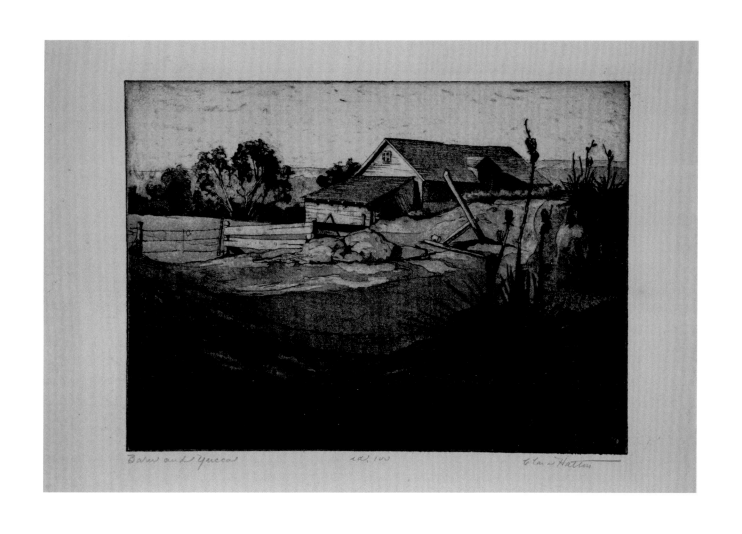

Barn and Yucca, 1930s
Etching and aquatint with drypoint on laid paper

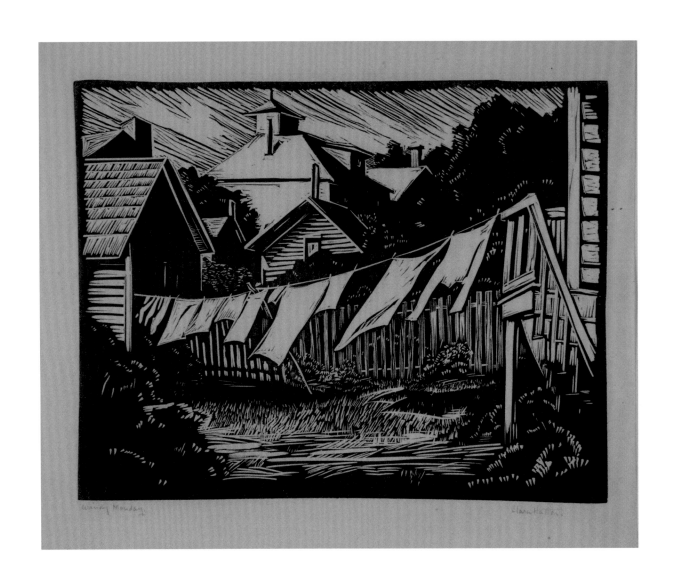

Windy Monday, 1930s
Linoleum cut on mulberry paper

Clip with monogram (OHS),
ca. 1930
Silver and enamel

Clip with monogram (GES),
ca. 1930
Silver and enamel

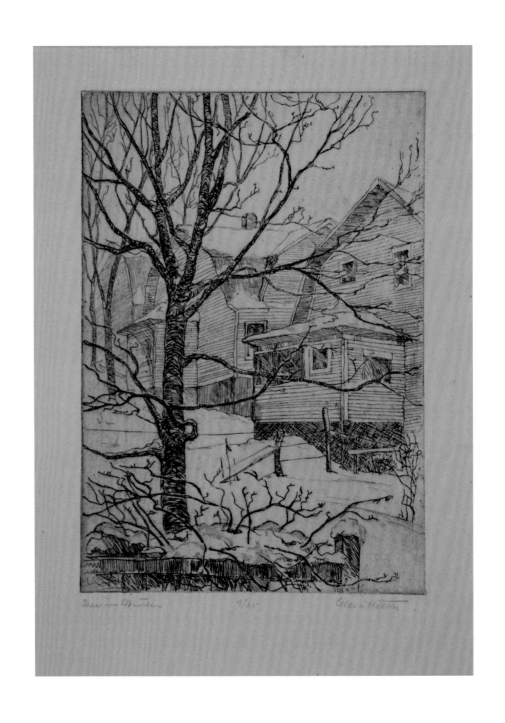

Tree in Winter, ca. 1932
Etching on wove paper

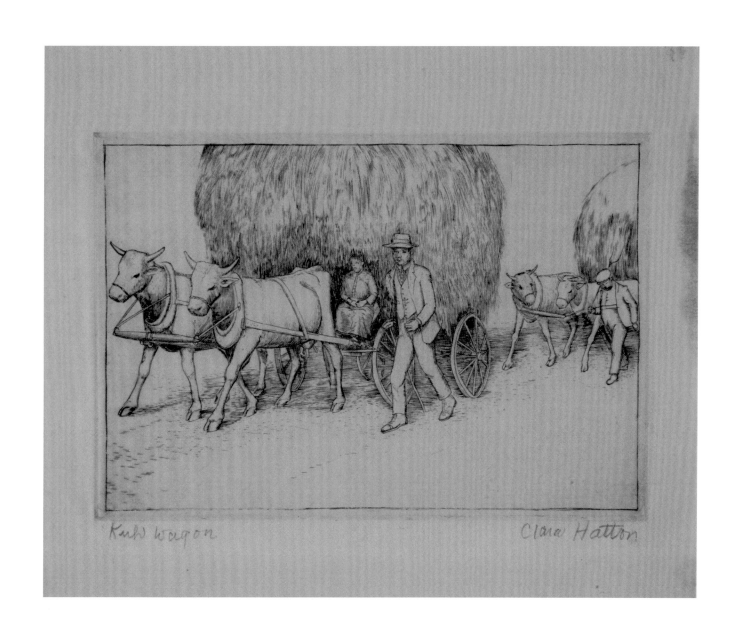

Kuh Wagon, 1935
Engraving on laid paper

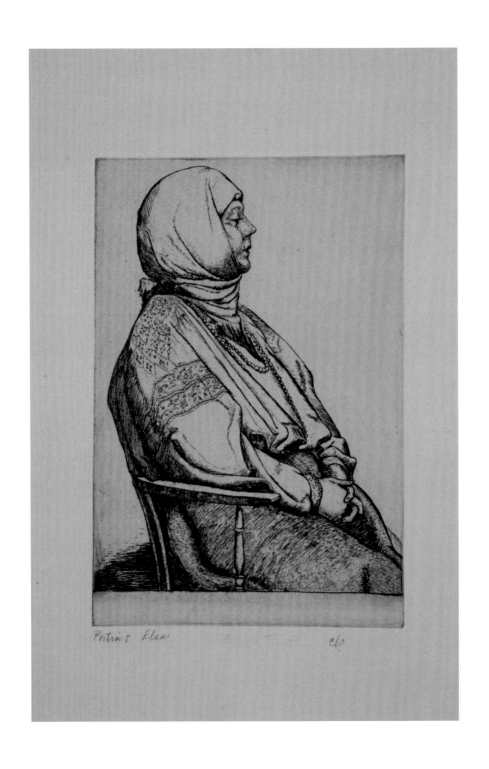

Portrait Elsa, 1935
Engraving on wove paper

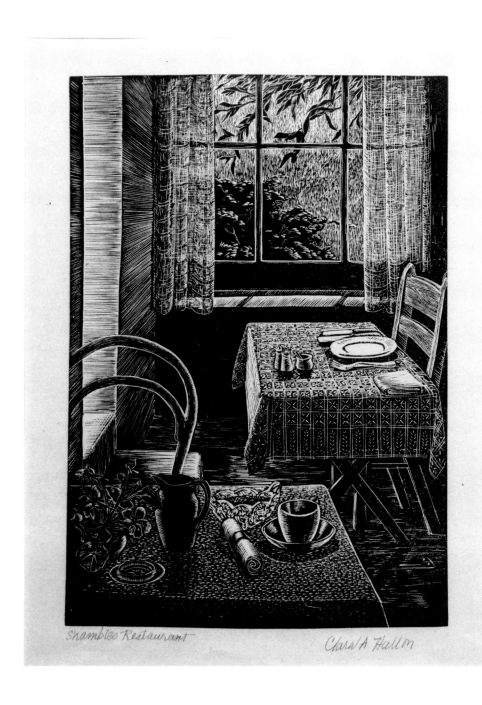

Shambles Restaurant, 1935,
printed after 1970
Wood engraving on wove
paper

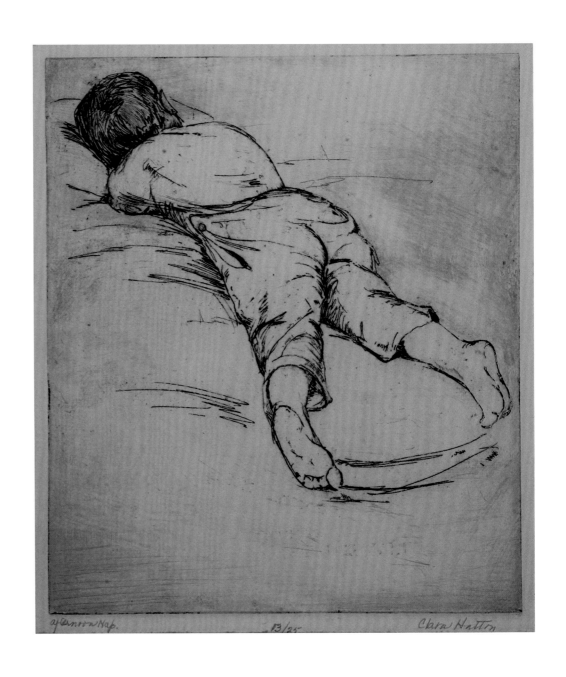

Afternoon Nap, 1936
Etching on wove paper

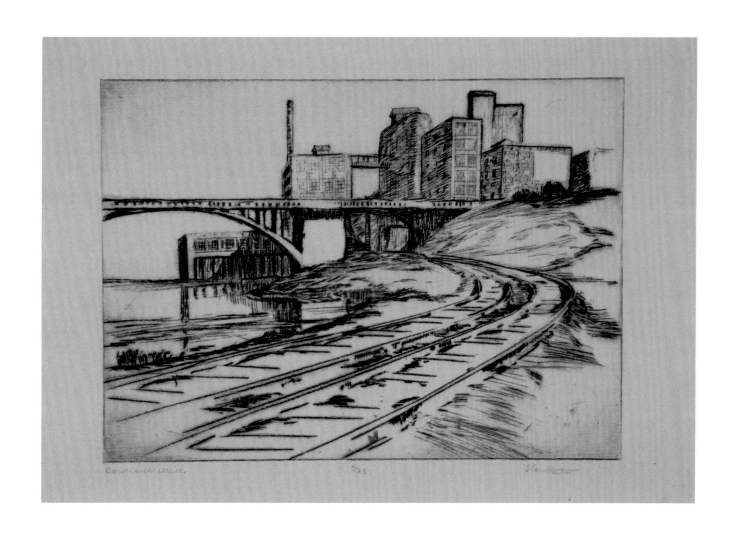

Bowersock Mills, 1936
Drypoint on machine-laid paper

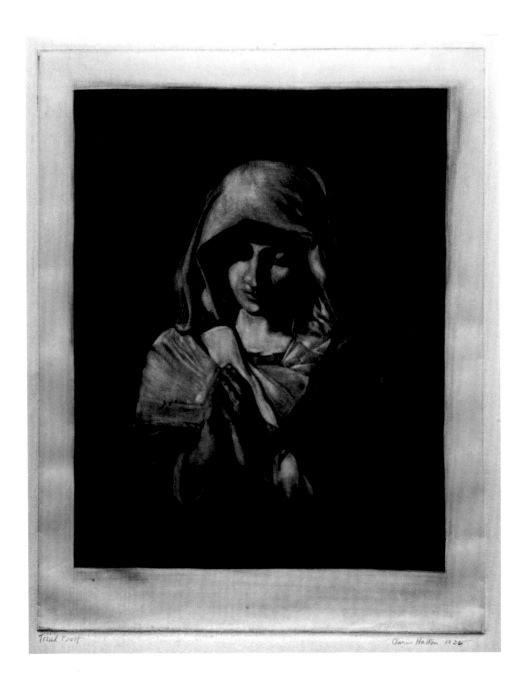

After Sassoferrato
(Giovanni Battista Salvi,
1609-85)
The Virgin in Prayer, 1936
Mezzotint on wove paper

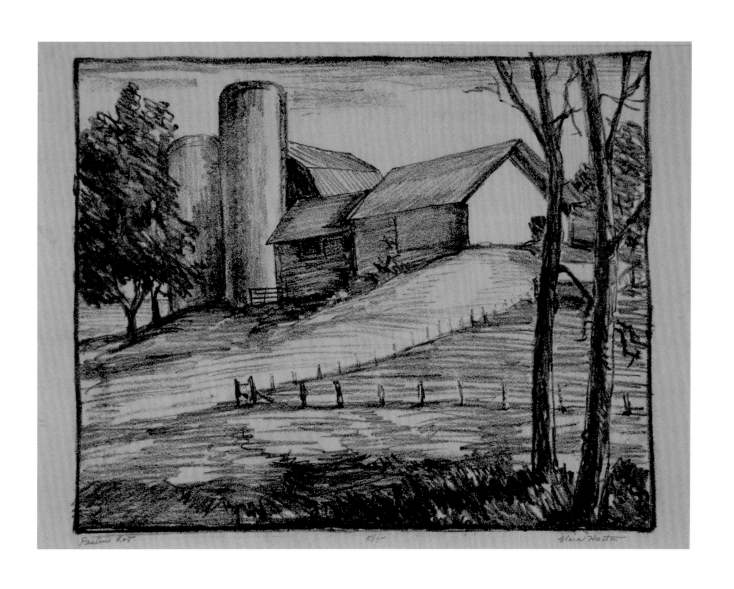

Pasture Lot, 1930s or 1940s
Lithograph on wove paper

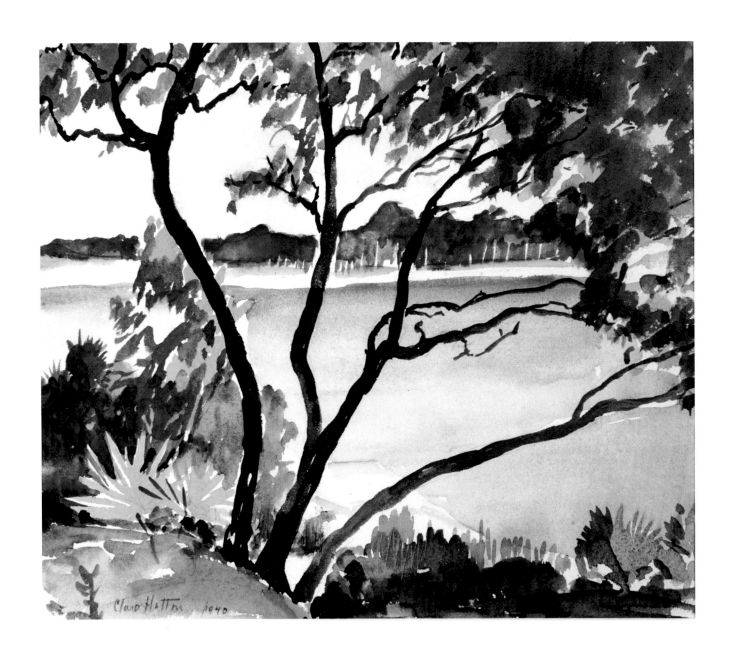

Landscape, 1940
Watercolor with graphite
underdrawing on wove paper

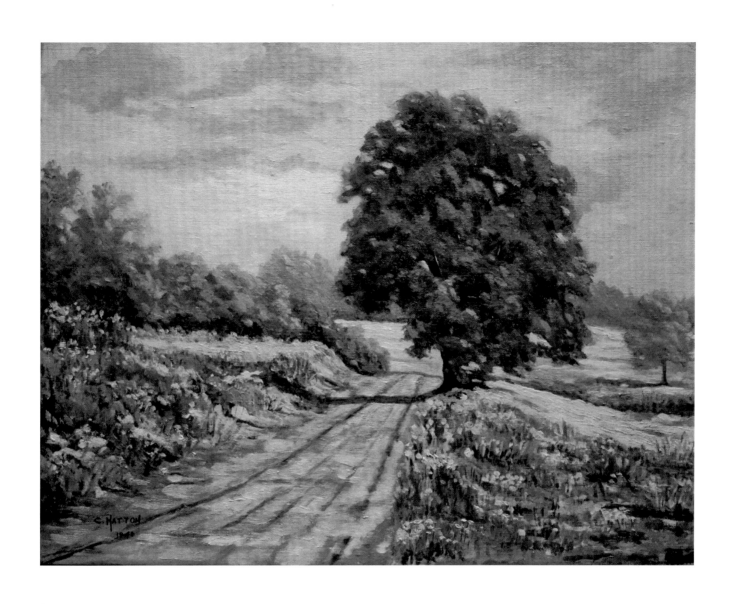

Red Tree, 1940
Oil on canvas board

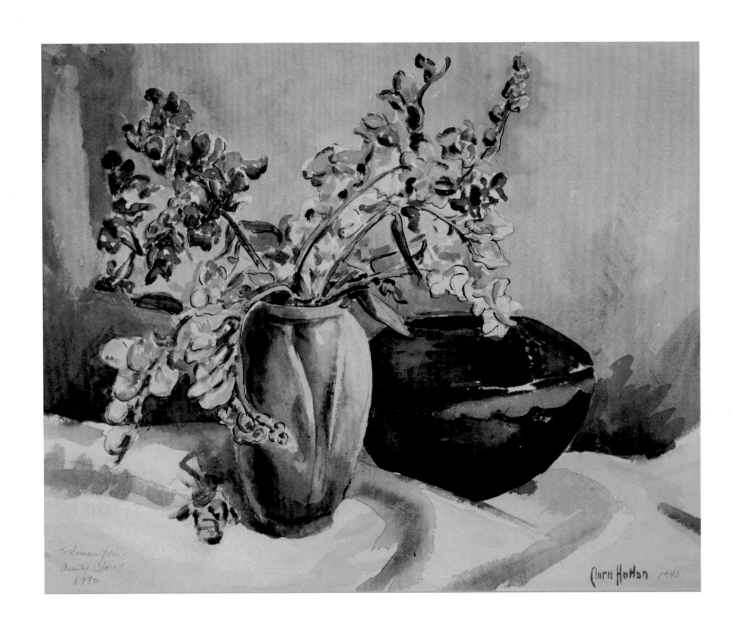

Still life with floral arrangement and black pottery, 1940
Watercolor with graphite on paper

54

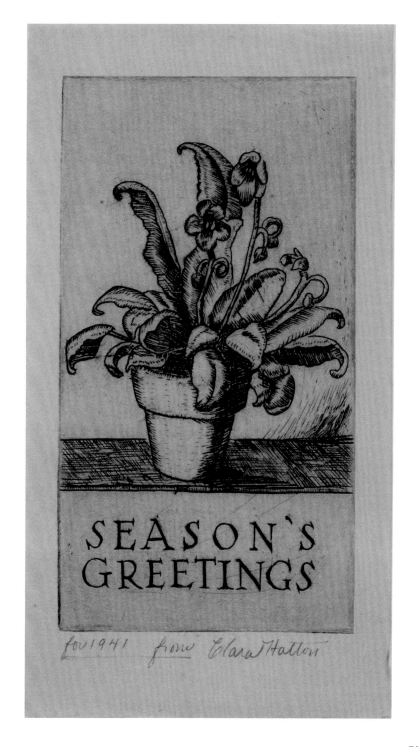

Season's Greetings, 1941
Etching on wove paper

The Leopard and the Fox

The Leopard, one day, took it into his head to value himself upon the great variety and beauty of his spots. Truly he saw no reason why even the Lion should take place before him, since he could not show so beautiful a skin. As for the rest of the wild beasts of the forest, he treated them all, without distinction, in the most haughty, disdainful manner. But the Fox, being among them, went up to him and with a great deal of spirit and resolution told him that he was mistaken in the value he was pleased to set upon himself, since persons of judgment are not used to form their opinion of merit from an outside appearance, but by considering the good qualities and endowments with which the mind is stored.

Application: How much more pleasing and powerful would beauty prove if it were not so frequently spoiled by the affectation and conceit of its possessor.

The Leopard and the Fox, 1944
Engraving and letterpress on
wove paper

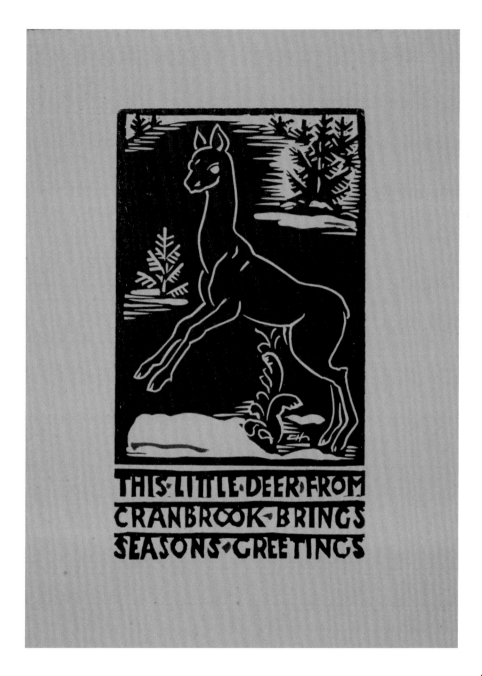

This Little Deer from Cranbrook Brings Season's Greetings,
ca. 1944
Block print with hand coloring on
card stock

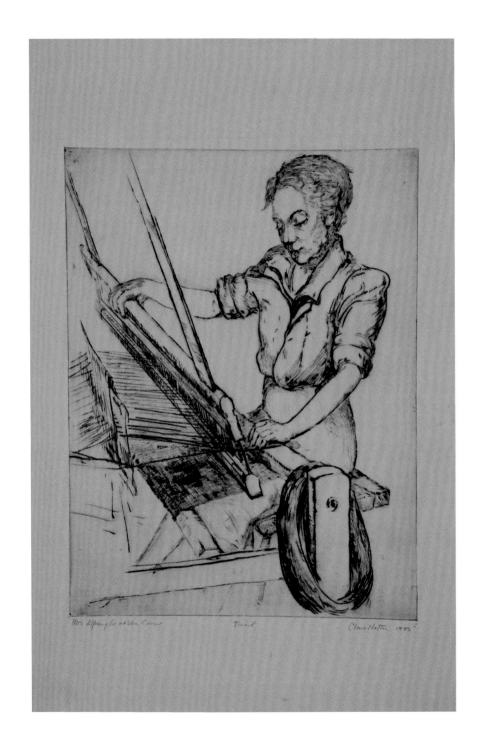

Mrs. Alpaugh at the Loom, 1945
Etching with drypoint on
wove paper

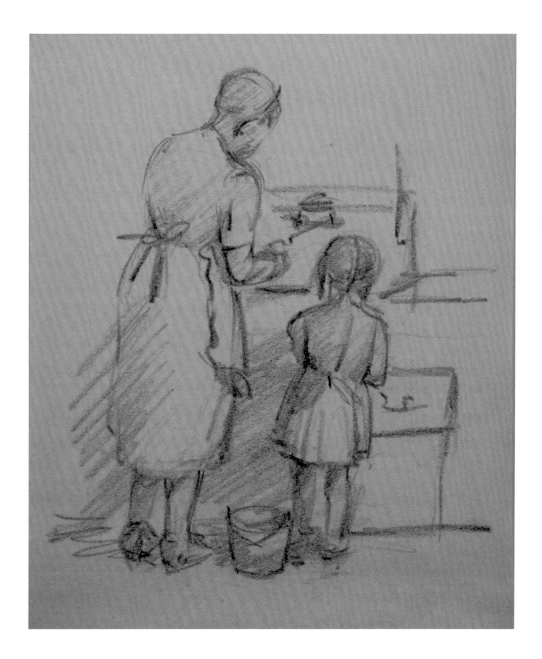

Grandma Hatton and Little Ora,
ca. 1946
Charcoal on wove paper

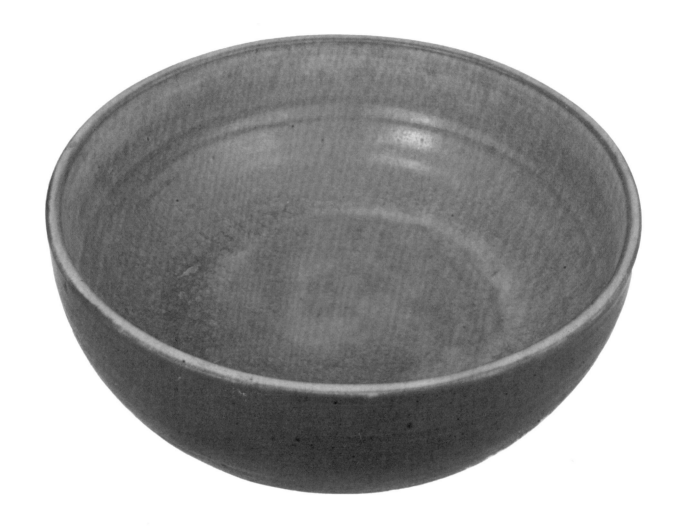

Bowl, 1956
Glazed ceramic

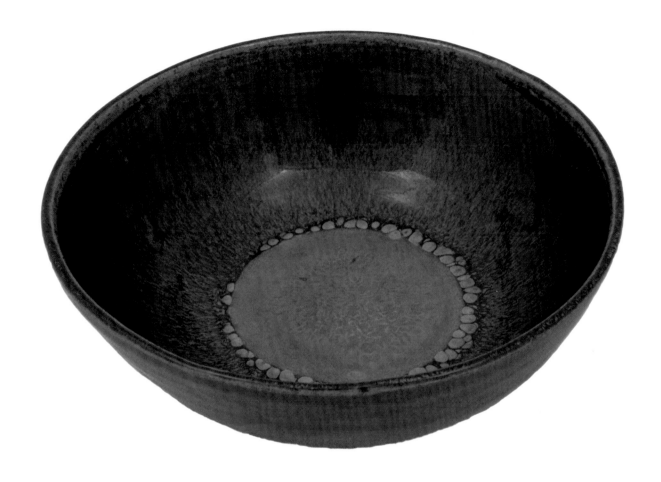

Bowl, date unidentified
Glazed ceramic

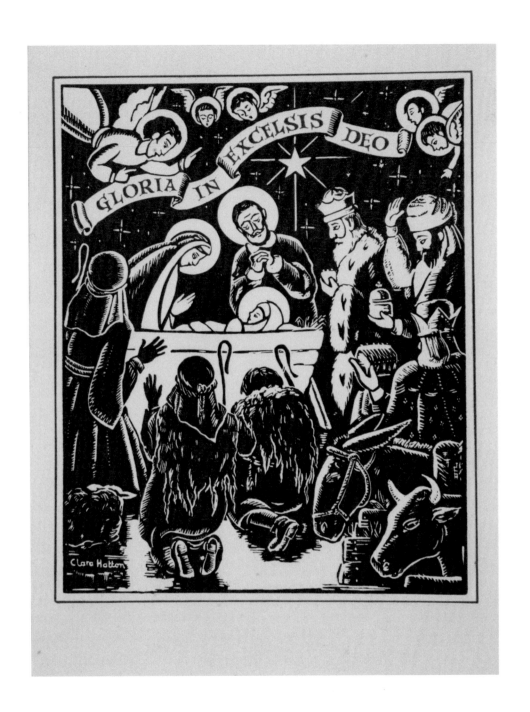

Gloria in excelsis Deo,
date unidentified
Block print with gold
powder on laid paper

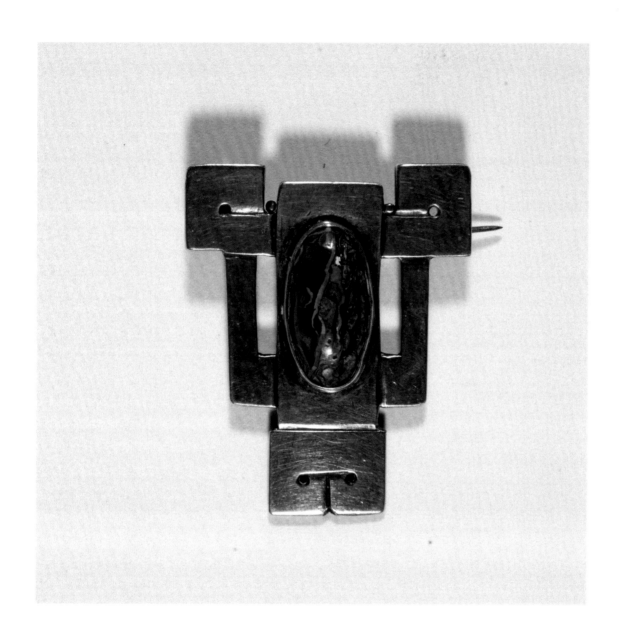

Pin, date unidentified
Silver and black opal

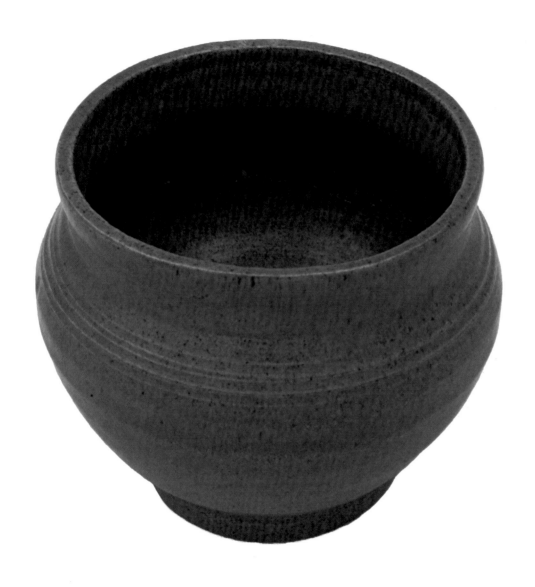

Pot, date unidentified
Glazed ceramic

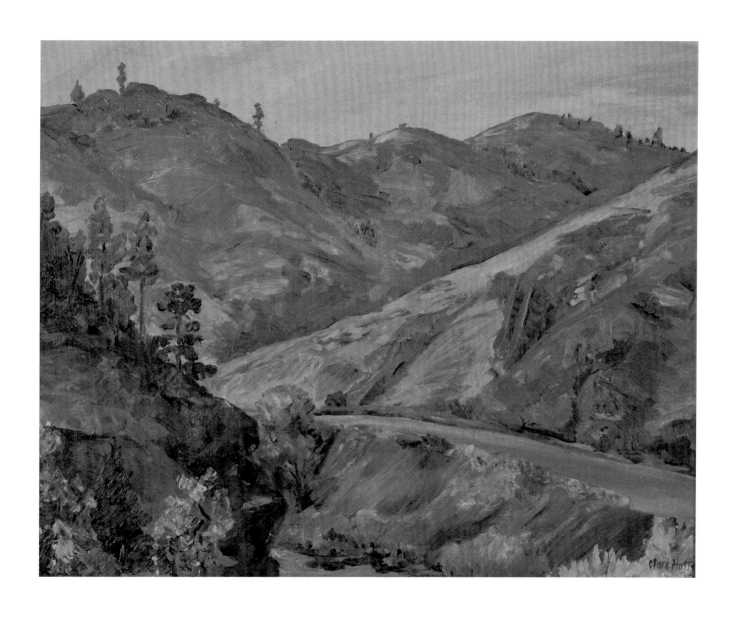

Canyon Landscape, Colorado
date unidentified
Oil on linen over board

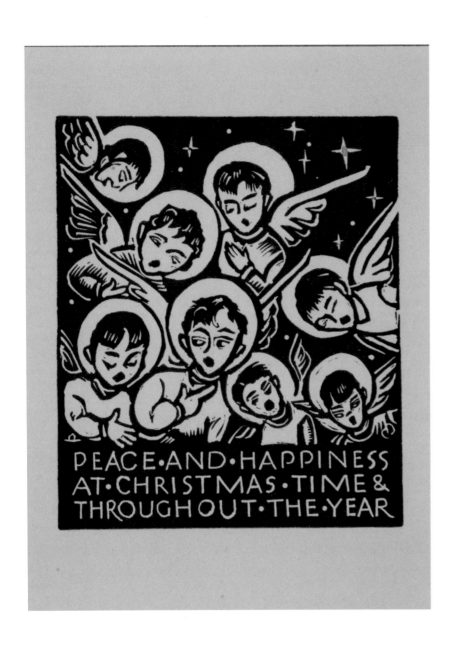

Peace and Happiness at Christmas Time
& Throughout the Year, 1956
Block print with gold leaf on wove paper

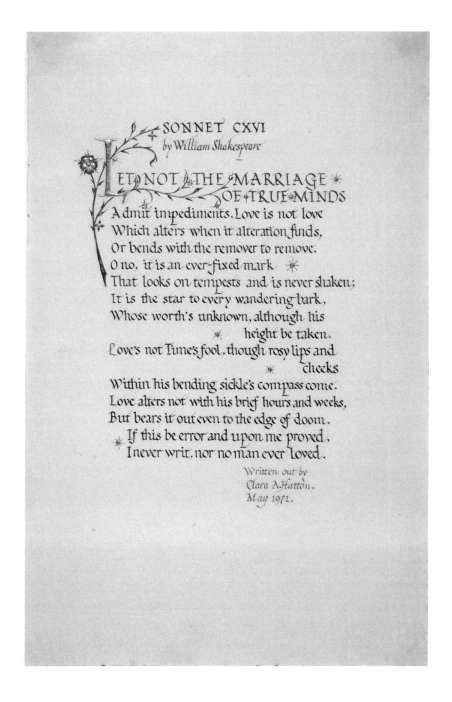

Sonnet CXVI, by William Shakespeare, 1971
Pen and ink with gold powder, ink,
and gold leaf on wove paper

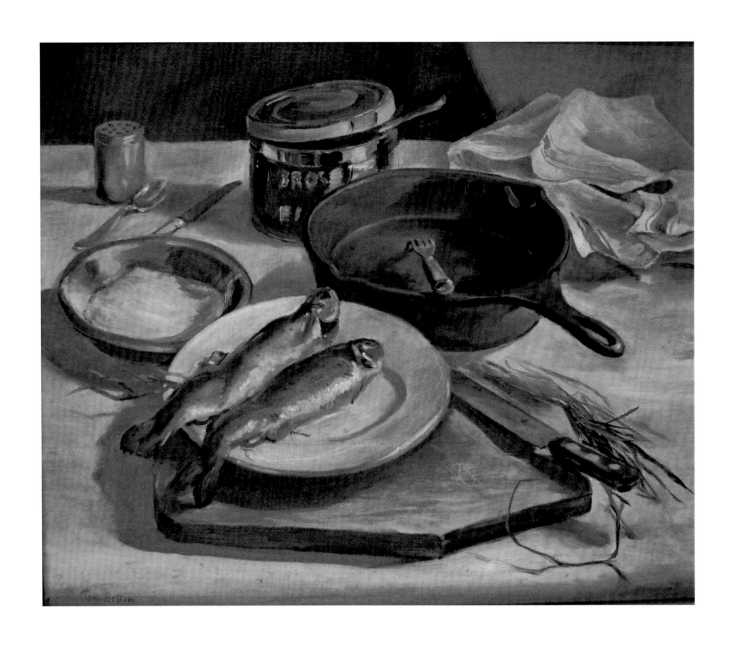

Fisherman's Breakfast, ca. 1965
Oil on linen

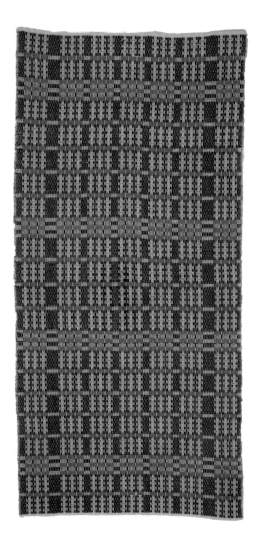

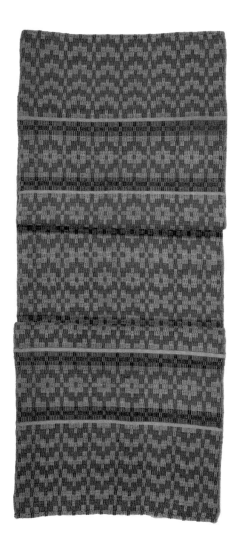

Table runner (red), date unidentified
Woven cotton

Table runner (blue), date unidentified
Woven cotton

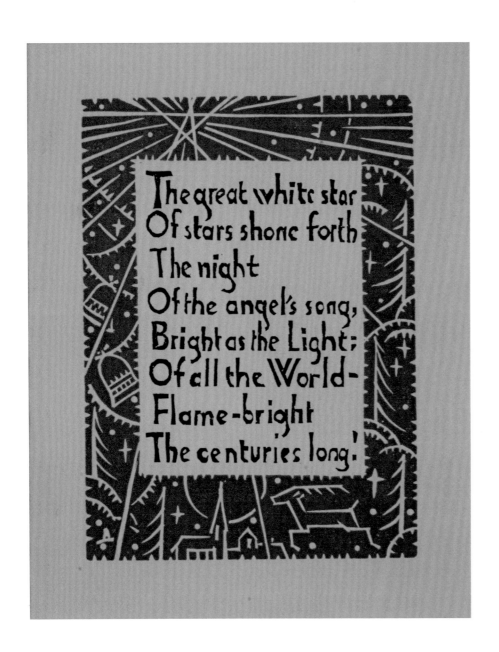

The great white star
Of stars shone forth
The night
Of the angel's song,
Bright as the Light:
Of all the World—
Flame-bright
The centuries long!

The great white star of stars shone forth…,
date unidentified
Block print with gold powder on card stock

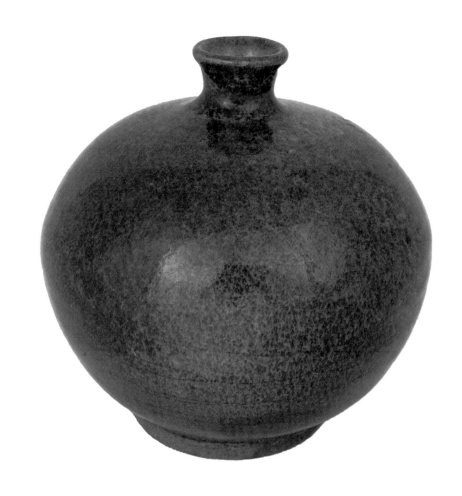

Vase, 1959
Glazed ceramic

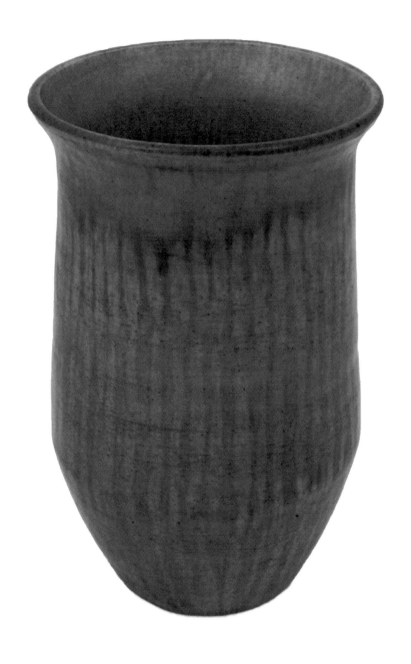

Vase, date unidentified
Glazed ceramic

Clara Hatton's paint box

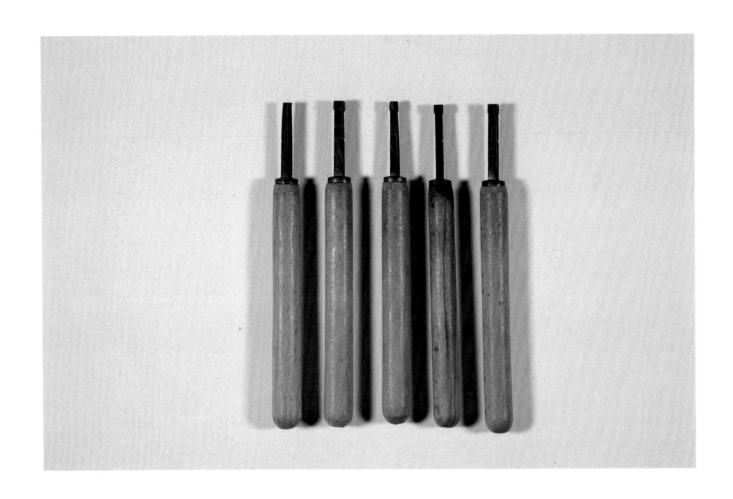

Emery Walker
24pt. Doves Press handle
letters and case
Brass and wood

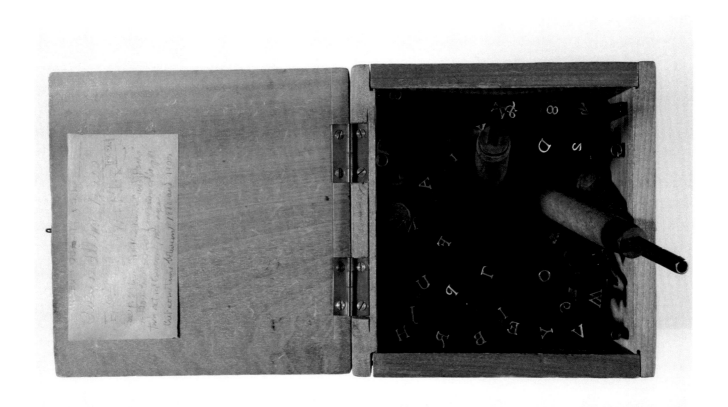

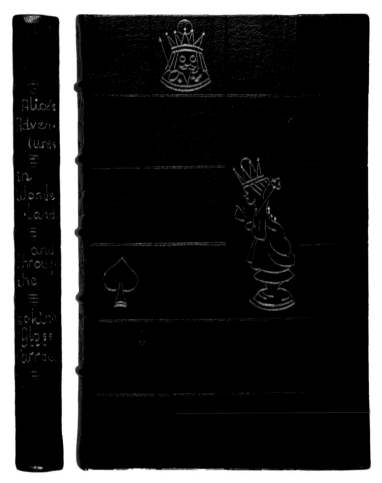

Lewis Carroll
Alice's Adventures in Wonderland
(New York: Three Sirens Press, ca. 1930)
Binding not dated

CHATTON stamped in blind inside front board at tail. Text has been re-sewn on raised cords and bound in full red leather (goat); spine titled in blind; letter forms were built up with gouges, line segments and other decorative brass hand tools; sewn endbands, top edge gilt. The charming cover decoration is blind tooled in a grid pattern to suggest a chess board. Black leather onlays fill in the board. Figures from the illustrated text were tooled in gold (built up with gouges, line segments and other decorative brass hand tools) complete the design, which continues onto the wide turn-ins. The endsheets are handmade Fabriano paper.[1]

1 Cataloguing texts pp. 76–84 provided by Karen Jones, collections conservator and master bookbinder, Denver, Colorado.

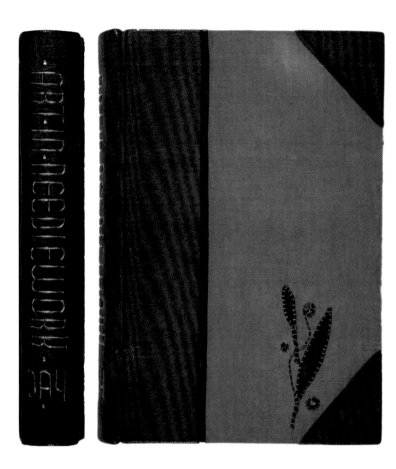

Lewis F. Day and Mary Buckle
Art in Needlework
(London: B.T. Batsford Ltd, 1914)
Binding not dated

Text has been re-sewn on tapes and bound in half leather (goat); spine titled in gold. The letter forms were built up with gouges, line segments, and other decorative brass hand tools. The sides are covered in a thin linen fabric. An applique of leather and embroidery thread decorates the lower right corner; sewn endbands; gold edge gilding at head.

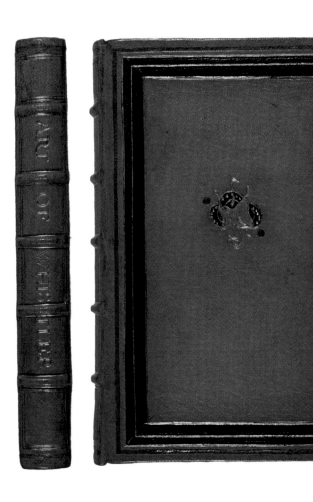

Elizabeth Robins Pennell and Joseph Pennell
The Art of Whistler
(New York: Modern Library, 1928)
Binding not dated or signed

Text has been re-sewn on raised cords and bound in full leather (goat); spine titled in gold, using the 24pt. Doves handle letters; sewn endbands, gold edge gilding. The cover decoration consists of inlaid frames of leather strips in contrasting colors, outlined with gold on both front and rear boards. A decorative center ornament on the front cover is built up with decorative brass hand tools and leather onlays. The decorative endsheets are Cockerell papers.

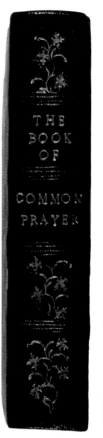 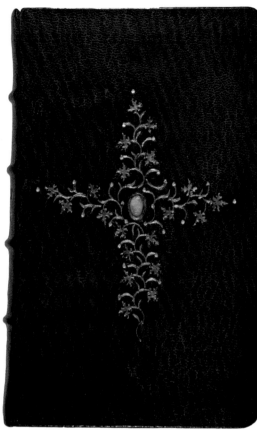

The Book of Common Prayer
(Oxford: Oxford University Press, 1944)
Binding not dated

Text has been re-sewn on raised cords and bound in full leather (goat); tooled in gold on covers and spine. On the front cover/board, an opal is inset in the center of a cruciform shape of floral elements. The design is built up from an assortment of gouges and other decorative brass hand tools; sewn endbands.

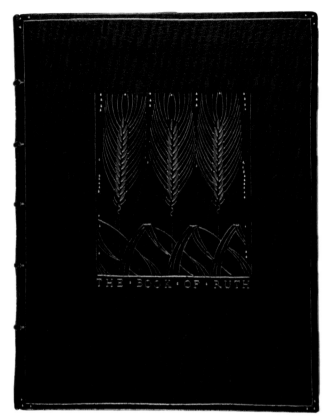

The Book of Ruth

According to the colophon, the text was scribed by C. Hatton in 1936, while studying at the Central School of Arts and Crafts, London, and bound after she returned to the US.

The text paper is a rag wove paper, made in England with deckle edges. The text was scribed in black and blue inks, with blue initials and pagination. The title page includes illuminated decoration and an illuminated initial. The text is sewn on raised cords, boards laced-on and bound in full leather (goat). The covers are tooled in a strong stylized design of wheat sheaves made from an assortment of gouges and decorative brass hand tools. The spine and front cover is titled in gold, using 24pt. Doves handle letters; sewn endbands; top edge gilt. The endsheets are of handmade Fabriano paper.

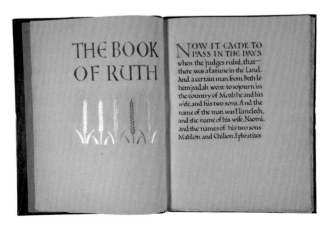

William Shakespeare
King Richard II
(London: J. M. Dent, 1905)
Binding not dated or signed

Text has been re-sewn on raised cords and bound in full red leather (Oasis Morocco goat); tooled in gold on covers and spine with leather onlays. The spine titling is stamped; cover design is geometric. Sewn endbands; gilt edges. The decorative endsheets are Cockerell papers. A paper slip in the binding notes a very short description and a penciled $20.00.

Henry Wadsworth Longfellow
Poems
(New York: A. L. Burt, 1901)

Note enclosed: "The first binding in leather made by Clara Hatton while a student of Rosemary Ketcham at the University of Kansas in 1925"

Text has been re-sewn on raised cords and bound in full leather (goat/levant morocco); tooled in gold and in blind on covers and spine; sewn endbands; gold edge gilding at head.

William Shakespeare
Romeo and Juliet
(London: J. M. Dent, 1908)
Binding not dated

HATTON stamped in gold inside rear board at tail. Text has been re-sewn on raised cords and bound in full leather (goat); tooled in gold on covers and spine with leather onlays. The letter forms on the spine and center floral ornament are built up with gouges and line segments. Sewn endbands; gilt edges. The decorative endsheets are Cockerell papers.

The Very Wise Minnow

Binding not dated
Text scribed by Clara Hatton in September
1935, before she started writing classes
at the Central School of Arts and Crafts,
London.

Bound in full leather (goat), with a whimsical
design of fish tooled in silver with leather
onlays. The design is built from an
assortment of gouges and other decorative
brass hand tools; sewn endbands; flat spine;
graphite or silver edge gilding at head.

Exhibition Checklist

Exhibition Checklist

Clara Anna Hatton
Born: October 19, 1901; Bunker
Hill, Kansas
Lived/worked: Lawrence, Kansas;
Fort Collins, Colorado; Salina,
Kansas
Died: June 27, 1991; Salina, Kansas

Note: All work is by Clara Hatton.
Dimensions are given in inches,
height preceding width, preceding
depth. Dimensions given for works
on paper are for the image, block,
or plate. Bindings and tools appear
at the end of the checklist. Unless
otherwise indicated, all work is
from the Collection of Ora Hatton
Shay.

Picking Dandelions, 1928
Oil on paperboard
10¾ x 13¾
Collection of Don and Carol Hatton

Pine and Aspens, 1930s
Oil on linen over paperboard
23¾ x 19¹⁵⁄₁₆
Collection of Don and Carol Hatton

Evening, 1929
Aquatint with etching and drypoint
on laid paper
4¹⁵⁄₁₆ x 6¹⁵⁄₁₆

Study for *Evening*, ca. 1929
Graphite on wove paper
9⁷⁄₁₆ x 7¹³⁄₁₆

Study for *Evening*, ca. 1929
Ink with graphite on wove paper
10¾ x 8¹⁄₁₆

Barn and Yucca, 1930s
Etching and aquatint with drypoint
on laid paper
4¹⁵⁄₁₆ x 6¹⁵⁄₁₆
Gregory Allicar Museum of Art,
CSU, 2006.116

Windy Monday, 1930s
Linoleum cut on mulberry paper
6¹⁵⁄₁₆ x 9¹⁄₁₆

Clip with monogram (OHS),
ca. 1930
Silver and enamel
2⅜ x ¹³⁄₁₆ x ¼

Clip with monogram (GES),
ca. 1930
Silver and enamel
2⅜ x 1 x ¼

Tree in Winter, ca. 1932
Etching on wove paper
7 x 4¹⁵⁄₁₆

Kuh Wagon, 1935
Engraving on laid paper
4¼ x 6⁵⁄₁₆

Portrait Elsa, 1935
Engraving on wove paper
6⁹⁄₁₆ x 4½

Shambles Restaurant, 1935,
printed after 1970
Wood engraving on wove paper
6⅞ x 4⅞
Gregory Allicar Museum of Art,
CSU, John and Yvonne Berland,
2006.337

Afternoon Nap, 1936
Etching on wove paper
7⅞ x 6⅞
Collection of Helen and Dick
Rewey

Bowersock Mills, 1936
Drypoint on machine-laid paper
$4\frac{15}{16} \times 6\frac{15}{16}$

After Sassoferrato (Giovanni
Battista Salvi, 1609-85)
The Virgin in Prayer, 1936
Mezzotint on wove paper
$8\frac{3}{4} \times 6\frac{15}{16}$

Pasture Lot, 1930s or 1940s
Lithograph on wove paper
$7\frac{1}{16} \times 9\frac{1}{16}$

Landscape, 1940
Watercolor with graphite
underdrawing on wove paper
$8\frac{1}{2} \times 11\frac{3}{8}$

Red Tree, 1940
Oil on canvas board
$13\frac{7}{8} \times 18$

*Still life with floral arrangement and
black pottery*, 1940
Watercolor with graphite on paper
$14\frac{3}{4} \times 18\frac{1}{8}$
Collection of Susan Elizabeth Gillin

Season's Greetings, 1941
Etching on wove paper
$4 \times 2\frac{3}{16}$

The Leopard and the Fox, 1944
Engraving and letterpress on wove
paper
$5\frac{1}{4} \times 3\frac{5}{16}$ (plate); $8\frac{5}{8} \times 12$ (sheet)

*This Little Deer from Cranbrook
Brings Season's Greetings*, ca. 1944
Block print with hand coloring on
card stock
$4\frac{5}{16} \times 2\frac{3}{8}$

Mrs. Alpaugh at the Loom, 1945
Etching with drypoint on wove
paper
$8\frac{15}{16} \times 6\frac{15}{16}$

Grandma Hatton and Little Ora, ca.
1946
Charcoal on wove paper
$9\frac{5}{8} \times 8$

Bowl, 1956
Glazed ceramic
$3\frac{1}{4} \times 8\frac{1}{8} \times 8\frac{1}{8}$

Bowl, date unidentified

Glazed ceramic
$2\frac{5}{8} \times 7\frac{1}{2} \times 7\frac{1}{2}$

Gloria in excelsis Deo, date
unidentified
Block print with gold powder on
laid paper
$5\frac{1}{8} \times 4\frac{1}{8}$

Pin, date unidentified
Silver and black opal
$1\frac{7}{16} \times 1\frac{1}{8} \times \frac{1}{4}$

Pot, date unidentified
Glazed ceramic
$4 \times 4\frac{1}{2} \times 4\frac{1}{2}$
Gregory Allicar Museum of Art,
CSU, gift of Ms. Dawn Kruger,
2012.3

Canyon Landscape, Colorado,
date unidentified
Oil on linen over board
$19\frac{1}{2} \times 15\frac{1}{4}$
Collection of Don and Carol Hatton

*Peace and Happiness at Christmas
Time & Throughout the Year*, 1956
Block print with gold leaf on wove
paper, $4 \times 3\frac{7}{8}$

Sonnet CXVI, by William Shakespeare, 1971
Pen and ink with gold powder, ink, and gold leaf on wove paper
18¼ x 12

Fisherman's Breakfast, ca. 1965
Oil on linen
20 x 24
Gregory Allicar Museum of Art, CSU, 2006.120, conserved with support from the Greenwood Fund

Table runner (red), date unidentified
Woven cotton
31¼ x 15⅛
Collection of Todd Goodheart

Table runner (blue), date unidentified
Woven cotton
53¼ x 13½
Collection of Todd Goodheart

The great white star of stars shone forth..., date unidentified
Block print with gold powder on card stock
4 x 3

Vase, 1959
Glazed ceramic
5⁵⁄₁₆ x 5⅝ x 5⅝

Vase, date unidentified
Glazed ceramic
5¾ x 3¾ x 3¾

Clara Hatton's paint box

Emery Walker (born in London, England, 1851–1933)
24pt. Doves Press handle letters and case
Brass and wood

BINDINGS

Lewis Carroll, *Alice's Adventures in Wonderland* (New York: Three Sirens Press, ca. 1930)
8¼ x 5½ x ⅞
Binding not dated

Lewis F. Day and Mary Buckle
Art in Needlework
(London: B.T. Batsford Ltd, 1914)
7⁵⁄₁₆ x 5⅛ x 1⅛
Binding not dated

Elizabeth Robins Pennell and Joseph Pennell, *The Art of Whistler* (New York: Modern Library, 1928)
6⅝ x 4½ x ¾
Binding not dated or signed

The Book of Common Prayer
(Oxford: Oxford University Press, 1944)
6 x 3½ x 1⅛
Binding not dated

The Book of Ruth
11¾ x 9⁵⁄₁₆ x ½
Binding not dated
William Shakespeare, *King Richard II* (London: J. M. Dent, 1905)
5³⁄₁₆ x 4 x ¾
Binding not dated or signed

Henry Wadsworth Longfellow, *Poems* (New York: A. L. Burt, 1901)
7½ x 5⅛ x 1½
Bound 1925

William Shakespeare, *Romeo and Juliet* (London: J. M. Dent, 1908)
5³⁄₁₆ x 4 x ¾
Binding not dated

The Very Wise Minnow
7¼ x 5 x ⅝
Binding not dated

About the Authors

Bill North
Independent curator and Director of the Clara Hatton Center, Salina, Kansas

Independent curator Bill North was the Executive Director of the Salina Art Center in Salina, Kansas, from 2012 to 2019. Prior to that, he was the Senior Curator at the Marianna Kistler Beach Museum of Art, Kansas State University from 1995 to 2012. He has also held curatorial positions at the Kresge Art Museum, Michigan State University and the Spencer Museum of Art, University of Kansas. A specialist in the history of American prints and print culture of the 1930s and '40s, North has organized over sixty exhibitions and has authored or contributed to numerous articles, books, and exhibition catalogues.

Dr. Emily Moore
Associate Curator of North American Art, Gregory Allicar Museum of Art, and Associate Professor of Art History, Department of Art and Art History, Colorado State University

Emily Moore is Associate Professor of Art History at CSU, where she teaches courses in Native American and American art history. She is also Associate Curator of North American Art at the Gregory Allicar Museum at CSU. Raised in Ketchikan, Alaska, Emily earned her MA (2007) and PhD (2012) in the History of Art from the University of California, Berkeley; she also has an MFA (2004) in Creative Writing from West Virginia University. Her research focuses on historical and contemporary arts from the Northwest Coast, as well as the inclusion (and exclusion) of Native arts in American and world art histories.

CSU Land Acknowledgments

Colorado State University acknowledges, with respect, that the land we are on today is the traditional and ancestral homelands of the Arapaho, Cheyenne, and Ute Nations and peoples. This was also a site of trade, gathering, and healing for numerous other Native tribes. We recognize the Indigenous peoples as original stewards of this land and all the relatives within it. As these words of acknowledgment are spoken and heard, the ties Nations have to their traditional homelands are renewed and reaffirmed.

CSU is founded as a land-grant institution, and we accept that our mission must encompass access to education and inclusion. And, significantly, that our founding came at a dire cost to Native Nations and peoples whose land this University was built upon. This acknowledgment is the education and inclusion we must practice in recognizing our institutional history, responsibility, and commitment.

Partial support for the exhibitions and programs at the Gregory Allicar Museum of Art is provided by the FUNd endowment at Colorado State University and by Colorado Creative Industries. CCI and its activities are made possible through an annual appropriation from the Colorado General Assembly and federal funds from the National Endowment for the Arts.